RICHARD WOLLHEIM

Art and its Objects

PENGUIN BOOKS

Penguin Books Ltd, Harmondsworth,
Middlesex, England
Penguin Books, 625 Madison Avenue,
New York, New York 10022, U.S.A.
Penguin Books Australia Ltd, Ringwood,
Victoria, Australia
Penguin Books Canada Ltd, 2801 John Street,
Markham, Ontario, Canada L3R 1B4
Penguin Books (N.Z.) Ltd,
182–190 Wairau Road, Auckland 10, New Zealand

First published in the U.S.A.
by Harper & Row 1968
Published in Pelican Books 1970
Reissued in Peregrine Books 1975
Reprinted 1978

Made and printed in Great Britain by
Hazell Watson & Viney Ltd, Aylesbury, Bucks
Set in Linotype Pilgrim

Peregrine Books

Art and its Objects

'To say that it is the best modern book on philosophical aesthetics is fainter praise than it deserves. In about 50,000 words it covers a wide range of problems with great verve and originality. Professor Wollheim is a highly sophisticated man, as is shown by the vast range of his allusions to works of art of all kinds, by the mannered but engaging elegance of his style and by the authority with which he handles a large number of complex disciplines that overlap marginally in the field of his interest – the kind of authority that consorts with high lucidity and the brisk exclusion of inessentials. He has never written anything better, nor, on this subject, has anyone else' – Anthony Quinton in the *Listener*

'This excellent book will certainly be compulsory reading for students of aesthetics for many years' – Peter Jones in the *British Journal of Aesthetics*

Richard Wollheim has been Grote Professor of Philosophy of Mind and Logic in the University of London since 1963. Born in 1923, he was educated at Westminster School and Balliol College, Oxford. He served in the army in Northern Europe during the war before joining University College, London, as Assistant Lecturer in 1949; he became Lecturer in 1951 and Reader in 1960. He was visiting Professor at the University of Columbia from 1959 to 1960 and again in 1970, and at Visca-Bharata University in West Bengal in 1968, and at the University of Minnesota in 1972. He has been a President of the Aristotelian Society (1967–8), and Vice-President of the British Society of Aesthetics since 1969. He has contributed articles to philosophical and literary journals, and is also the author of *Socialism and Culture* (1961), *F. H. Bradley* (1959), *On Drawing an Object* (1965), *A Family Romance*, a novel (1969), *Freud* (1971) and *On Art and Mind*, essays and lectures (1973). He has also edited numerous books, including *F. H. Bradley, Ethical Studies* (1961), *Adrian Stokes, Selected Writings* (1972) and *J. S. Mill, Three Essays* (1975).

Cover design by John Golding

for Adrian Stokes

The quotation which appears on pages 139–40 is from *Letters of Mozart and His Family*, edited by E. Anderson (2nd edition, 1966), by permission of St Martin's Press, Macmillan and Company Ltd, of London and Toronto

Contents

Preface to the Pelican Edition

'Nothing is positive about art except that it is a word', the painter de Kooning has written. We could rewrite this more precisely as: Nothing is positive about art except that it is a concept.

We look at paintings, we read poetry, we listen to Bach or Stravinsky: and we are aware, inevitably, that the object of our attention is a work of art. A work, in the sense of a product of human labour: and also something that falls under the concept of art. We write a novel, we compose a piece of music, we make a pot. And once again, not merely is there, at the end, a piece of work, but the work – our work, this time – has been regulated by the concept of art.

So, as the audience of art or as the makers of it, we seem to be engaged simultaneously with artefacts and with a concept. Art, and its objects, come indissolubly linked. And if we sometimes feel that the concept only obscures the object and could as well be dropped: or alternatively, that the concept is all we need and that the day of the object is over; in neither case do we progress far beyond a gesture. The least of all changes is when we substitute for art anti-art. Then indeed we seem to be dealing with words not concepts.

Aesthetics, then, may be thought of as the attempt to understand this envelope in which works of art invariably arrive. It connects both with our understanding

of art and with our understanding of society: and may well be vital to both. *Art and its Objects* has been written in this belief.

This essay is an expanded version of an essay in *The Harper Guide to Philosophy* edited by Arthur Danto. I wish to express my gratitude to those who have given me encouragement, advice and assistance: Arthur Danto, Bernard Williams, Adrian Stokes, Michael Podro, Margaret Cohen, Katherine Backhouse, Nikos Stangos and Deborah Rogers. John Golding has generously designed the cover for this edition, and I should like to thank Penguin Books for their permission to use it, and Peter Wright for kindly editorial aid.

R.W.

The Argument

resentation, resemblance and seeing-as, and the suggestion made that resemblance might be understood in terms of seeing-as rather than vice versa; the introduction of intention into any such analysis.

15–19 The difficulty presented by Expression or expressive properties. Two crude causal views of expression rejected. Natural expression and 'correspondences'.

*

20 The physical-object hypothesis to be strengthened by a consideration of alternative hypotheses about the work of art: specifically, over those areas of art where the physical-object hypothesis gains a foothold (cf. 9–10).

21 The Ideal theory, i.e. the theory that works of art are mental entities, and the Presentational theory, i.e. the theory that works of art have only immediately perceptible properties, introduced.

22–3 The Ideal theory considered. Two objections raised: that the theory would make art private, and that it disregards the medium. (The *bricoleur* problem, or the problem of art's diversity or arbitrariness introduced.)

24 The Ideal theory and the Presentational theory contrasted. Objections to the Presentational theory to be considered under two headings:

those which dispute the exhaustiveness of the distinction between immediately and mediately perceptible properties, and those which insist that works of art possess properties other than the immediately perceptible.

25–31 The first set of objections to the Presentational theory considered. Difficulties for the exhaustive distinction between immediately and mediately perceptible properties are presented by meaning-properties and expression-properties. Sound and Meaning in poetry and the so-called 'music of poetry': the representation of movement: the representation of space ('tactile values'). The Gombrich argument concerning expression. (In the course of this discussion the notion of Iconicity briefly introduced.)

31–4 The second set of objections to the Presentational theory considered. Difficulties presented by properties that indubitably are not immediately perceptible, but are inherent to art. Genres and the 'radical of presentation': the spectator's expectations and the artist's intentions: the concept of art as something that the spectator must bring with him. The discussion broken off for a parenthesis.

*

35–7 The promise to consider those arts where the work of art clearly cannot be identified with a physical object now redeemed. Types and tokens, and the claim made that types may possess

*

Art and its Objects

'What is art?' 'Art is the sum or totality of works of art.'
'What is a work of art?' 'A work of art is a poem, a paint-
ing, a piece of music, a sculpture, a novel. . . .' 'What is
a poem? a painting? a piece of music? a sculpture? a
novel? . . .' 'A poem is . . ., a painting is . . ., a piece of
music is . . .' a sculpture is . . .' a novel is . . .'

It would be natural to assume that, if only we could fill
in the gaps in the last line of this dialogue, we should
have an answer to one of the most elusive of the tradi-
tional problems of human culture: the nature of art.
The assumption here is, of course, that the dialogue, as
we·have it above, is consequential. This is something
that, for the present, I shall continue to assume.

2

It might, however, be objected that, even if we could
succeed in filling in the gaps on which this dialogue ends,
we should still not have an answer to the traditional
question, at any rate as this has been traditionally in-
tended. For that question has always been a demand for a
unitary answer, an answer of the form 'Art is . . .';
whereas the best we could now hope for is a plurality
of answers, as many indeed as the arts or media that we
initially distinguish. And if it is now countered that we
could always get a unitary answer out of what we would
then have, by putting together all the particular answers

into one big disjunction, this misses the point. For the traditional demand was certainly, if not always explicitly, intended to exclude anything by way of an answer that had this degree of complexity: precisely the use of the word 'unitary' is to show that what is not wanted is anything of the form 'Art is (whatever a poem is), or (whatever a painting is), or. . . .'

But why should it be assumed, as it now appears to be, that, if we think of Art as being essentially explicable in terms of different kinds of work of art or different arts, we must abandon hope of anything except a highly complex conception of Art? For are we not overlooking the possibility that the various particular answers, answers to the questions What is a poem?, a painting?, etc., may, when they come, turn out to have something or even a great deal in common, in that the things they define or describe (i.e. works of art in their kinds) have many shared properties. For if this were so, then we would not have to resort to, at any rate we would not be confined to, mere disjunction. In what would be the area of overlap, we would have a base for a traditional type of answer: even if it later emerged that we could not move forward from this base, in that beyond a certain point the different arts remained intractably particular. For what this would show is that the traditional demand could not be satisfied in its totality, not that it was wrong ever to make it.

3

A procedure now suggests itself: and that is that what we should do is to try and first set out the various particular definitions or descriptions – what a poem is, what a painting is, etc. – and then, with them before us, see whether they have anything in common and, if they have, what it

is. But though this procedure might have much to rec-
ommend it on grounds of thoroughness (later we may
have to question this), it is barely practical. For it is un-
likely that we could ever complete the initial or pre-
paratory part of the task.

I shall, therefore, concede this much at least,
procedurally, that is, to the objections of the tradition-
alist: that I shall start with what I have called the over-
lap. Instead of waiting for the particular answers and
then seeing what they have in common, I shall try to
anticipate them and project the area over which they are
likely to coincide. And if this is now objected to on
grounds that it reverses the proper order of inquiry, in
that we shall be invited to consider and pronounce upon
hypotheses before examining the evidence upon which
they are supposedly based, my argument would be that
we all do have in effect, already inside us, the requisite
evidence. Requisite, that is, for the purpose, for the com-
paratively limited purpose, to hand: we all do have such
experience of poetry, painting, music, etc. that, if we
cannot (as I am sure we cannot) say on the basis of it
what these things are, we can at least recognize when we
are being told that they are something which in point of
fact they are not. The claim has been made that human
experience is adequate for the falsification, but never for
the confirmation, of a hypothesis. Without committing
myself either way on this as a general philosophical
thesis, I think that it is true enough in this area, and it is
upon the asymmetry that it asserts that the procedure I
propose to follow is based.

This procedure will bring us into contact at many
points with certain traditional theories of art. But it is
worth reiterating that it is no part of my present inten-
tion either to produce such a theory myself or to consider

existing theories as such. There is an important difference between asking what Art is, and asking what (if anything) is common to the different kinds of work of art or different arts: even if the second question (my question) is asked primarily as a prelude to, or as prefatory of, the first.

4

Let us begin with the hypothesis that works of art are physical objects. I shall call this for the sake of brevity the 'physical-object hypothesis'. Such a hypothesis is a natural starting point: if only for the reason that it is plausible to assume that things are physical objects unless they obviously aren't. Certain things very obviously aren't physical objects. Now though it may not be obvious that works of art are physical objects, they don't seem to belong among these other things. They don't, that is, immediately group themselves along with thoughts, or periods of history, or numbers, or mirages. Furthermore, and more substantively, this hypothesis accords with many traditional conceptions of Art and its objects and what they are.

5

Nevertheless the hypothesis that all works of art are physical objects can be challenged. For our purposes it will be useful, and instructive, to divide this challenge into two parts: the division conveniently corresponding to a division within the arts themselves. For in the case of certain arts the argument is that there is no physical object that can with any plausibility be identified as the work of art: there is no object existing in space and time (as physical objects must) that can be picked out and thought of as a piece of music or a novel. In the case of

other arts – most notably painting and sculpture – the argument is that, though there are physical objects of a standard and acceptable kind that could be, indeed generally are, identified as works of art, such identifications are wrong.

The first part of this challenge is, as we shall see, by far the harder to meet. However it is, fortunately, not it, but the second part of the challenge, that potentially raises such difficulties for aesthetics.

6

That there is a physical object that can be identified as *Ulysses* or *Der Rosenkavalier* is not a view that can long survive the demand that we should pick out or point to that object. There is, of course, the copy of *Ulysses* that is on my table before me now, there is the performance of *Der Rosenkavalier* that I will go to tonight, and both these two things may (with some latitude, it is true, in the case of the performance) be regarded as physical objects. Furthermore, a common way of referring to these objects is by saying things like '*Ulysses* is on my table', 'I shall see *Rosenkavalier* tonight': from which it would be tempting (but erroneous) to conclude that *Ulysses* just is my copy of it, *Rosenkavalier* just is tonight's performance.

Tempting, but erroneous; and there are a number of very succinct ways of bringing out the error involved. For instance, it would follow that if I lost my copy of *Ulysses*, *Ulysses* would become a lost work. Again, it would follow that if the critics disliked tonight's performance of *Rosenkavalier*, then they dislike *Rosenkavalier*. Clearly neither of these inferences is acceptable.

We have here two locutions or ways of describing the

facts: one in terms of works of art, the other in terms of copies, performances, etc. of works of art. Just because there are contexts in which these two locutions are interchangeable, this does not mean that there are no contexts, moreover no contexts of a substantive kind, in which they are not interchangeable. There very evidently are such contexts, and the physical-object hypothesis would seem to overlook them to its utter detriment.

7

But, it might now be maintained, of course it is absurd to identify *Ulysses* with my copy of it or *Der Rosenkavalier* with tonight's performance, but nothing follows from this of a general character about the wrongness of identifying works of art with physical objects. For what was wrong in these two cases was the actual physical object that was picked out and with which the identification was then made. The validity of the physical-object hypothesis, like that of any other hypothesis, is quite unaffected by the consequences of misapplying it.

For instance, it is obviously wrong to say that *Ulysses* is my copy of it. Nevertheless, there is a physical object, of precisely the same order of being as my copy, though significantly not called a 'copy', with which such an identification would be quite correct. This object is the author's manuscript: that, in other words, which Joyce wrote when he wrote *Ulysses*.

On the intimate connexion, which undoubtedly does exist, between a novel or a poem on the one hand and the author's manuscript on the other, I shall have something to add later. But the connexion does not justify us in asserting that one just is the other. Indeed, to do so seems open to objections not all that dissimilar from those we have just been considering. The critic, for instance, who

admires *Ulysses* does not necessarily admire the manuscript. Nor is the critic who has seen or handled the manuscript in a privileged position as such when it comes to judgement on the novel. And – here we have come to an objection directly parallel to that which seemed fatal to identifying *Ulysses* with my copy of it – it would be possible for the manuscript to be lost and *Ulysses* to survive. None of this can be admitted by the person who thinks that *Ulysses* and the manuscript are one and the same thing.

To this last objection someone might retort that there are cases (e.g., *Love's Labour Won*, Kleist's *Robert Guiscard*) where the manuscript is lost and the work is lost, and moreover the work is lost because the manuscript is lost. Of course there is no real argument here, since nothing more is claimed than that there are *some* cases like this. Nevertheless the retort is worth pursuing, for the significance of such cases is precisely the opposite of that intended. Instead of reinforcing, they actually diminish the status of the manuscript. For if we now ask, When is the work lost when the manuscript is lost?, the answer is, When and only when the manuscript is unique: but then this would be true for any copy of the work were it unique.

Moreover, it is significant that in the case of *Rosenkavalier* it is not even possible to construct an argument corresponding to the one about *Ulysses*. To identify an opera or any other piece of music with the composer's holograph, which looks the corresponding thing to do, is implausible because (for instance), whereas an opera can be heard, a holograph cannot be. In consequence it is common at this stage of the argument, when music is considered, to introduce a new notion, that of the ideal performance, and then to identify the piece of music

with this. There are many difficulties here: in the present context it is enough to point out that this step could not conceivably satisfy the purpose for which it was intended; that is, that of saving the physical-object hypothesis. For an ideal performance cannot be, even in the attenuated sense in which we have extended the term to ordinary performances, a physical object.

8

A final and desperate expedient to save the physical-object hypothesis is to suggest that all those works of art which cannot plausibly be identified with physical objects are identical with classes of such objects. A novel, of which there are copies, is not my or your copy but is the class of all its copies. An opera, of which there are performances, is not tonight's or last night's performance, nor even the ideal performance, but is the class of all its performances. (Of course, strictly speaking, this suggestion doesn't save the hypothesis at all: since a class of physical objects isn't necessarily, indeed is most unlikely to be, a physical object itself. But it saves something like the spirit of the hypothesis.)

However, it is not difficult to think of objections to this suggestion. Ordinarily we conceive of a novelist as writing a novel, or a composer as finishing an opera. But both these ideas imply some moment in time at which the work is complete. Now suppose (which is not unlikely) that the copies of a novel or the performances of an opera go on being produced for an indefinite period: then, on the present suggestion, there is no such moment, let alone one in their creator's lifetime. So we cannot say that *Ulysses* was written by Joyce, or that Strauss composed *Der Rosenkavalier*. Or, again, there is the problem of the unperformed symphony, or the poem of which

there is not even a manuscript: in what sense can we now say that these things even *exist*?

But perhaps a more serious, certainly a more interesting, objection is that in this suggestion what is totally unexplained is why the various copies of *Ulysses* are all said to be copies of *Ulysses* and nothing else, why all the performances of *Der Rosenkavalier* are reckoned performances of that one opera. For the ordinary explanation of how we come to group copies or performances as being of this book or of that opera is by reference to something else, something other than themselves, to which they stand in some special relation. (Exactly what this other thing is, or what is the special relation in which they stand to it is, of course, something we are as yet totally unable to say.) But the effect, indeed precisely the point, of the present suggestion is to eliminate the possibility of any such reference: if a novel or opera just is its copies or its performances, then we cannot, for purposes of identification, refer from the latter to the former.

The possibility that remains is that the various particular objects, the copies or performances, are grouped as they are, not by reference to some other thing to which they are related, but in virtue of some relation that holds between them: more specifically, in virtue of resemblance.

But, in the first place, all copies of *Ulysses*, and certainly all performances of *Der Rosenkavalier*, are not perfect matches. And if it is now said that the differences do not matter, either because the various copies or performances resemble each other in all relevant respects, or because they resemble each other more than they resemble the copies or performances of any other novel or opera, neither answer is adequate. The first answer begs

the issue, in that to talk of relevant respects presupposes that we know how, say, copies of *Ulysses* are grouped together: the second answer evades the issue, in that though it may tell us why we do not, say, reckon any of the performances of *Der Rosenkavalier* as performances of *Arabella*, it gives us no indication why we do not set some of them up separately, as performances of some third opera.

Secondly, it seems strange to refer to the resemblance between the copies of *Ulysses* or the performances of *Rosenkavalier* as though this were a brute fact: a fact, moreover, which could be used to explain why they were copies or performances of what they are. It would be more natural to think of this so-called 'fact' as something that itself stood in need of explanation: and, moreover, as finding its explanation in just that which it is here invoked to explain. In other words, to say that certain copies or performances are of *Ulysses* or *Rosenkavalier* because they resemble one another seems precisely to reverse the natural order of thought: the resemblance, we would think, follows from, or is to be understood in terms of, the fact that they are of the same novel or opera.

9

However, those who are ready to concede that some kinds of work of art are not physical objects will yet insist that others are. *Ulysses* and *Der Rosenkavalier* may not be physical objects, but the *Donna Velata* and Donatello's *St George* most certainly are.

I have already suggested (section 5) that the challenge to the physical-object hypothesis can be divided into two parts. It will be clear that I am now about to embark on the second part of the challenge: namely, that which

allows that there are (some) physical objects that could conceivably be identified as works of art, but insists that it would be quite erroneous to make the identification.

(To some, such a course of action may seem superfluous. For enough has been said to disprove the physical-object hypothesis. That is true; but the argument that is to come has its intrinsic interest, and for that reason is worth developing. Those for whom the interest of all philosophical argument is essentially polemical, and who have been convinced by the preceding argument, may choose to think of that which is to follow as bearing upon a revised or weakened version of the physical-object hypothesis: namely, that some works of art are physical objects.)

10

In the Pitti there is a canvas (No. 245) 85 cm x 64 cm: in the Museo Nazionale, Florence, there is a piece of marble 209 cm high. It is with these physical objects that those who claim that the *Donna Velata* and the *St George* are physical objects would naturally identify them.

This identification can be disputed in (roughly) one or other of two ways. It can be argued that the work of art has properties which are incompatible with certain properties that the physical object has; alternatively it can be argued that the work of art has properties which no physical object could have: in neither case could the work of art be the physical object.

An argument of the first kind would run: We say of the *St George* that it moves with life (Vasari). Yet the block of marble is inanimate. Therefore the *St George* cannot be that block of marble. An argument of the second kind would run: We say of the *Donna Velata* that it is exalted and dignified (Wölfflin). Yet a piece of canvas in the Pitti

cannot conceivably have these qualities. Therefore the *Donna Velata* cannot be that piece of canvas.

These two arguments, I suggest, are not merely instances of these two ways of arguing, they are characteristic instances. For the argument that there is an incompatibility of property between works of art and physical objects characteristically concentrates on the representational properties of works of art. The argument that works of art have properties that physical objects could not have characteristically concentrates on the expressive properties of works of art. The terms 'representational' and 'expressive' are used here in a very wide fashion, which, it is hoped, will become clear as the discussion proceeds.

II

Let us begin with the argument about representational properties. An initial difficulty here is to see exactly how the argument is supposed to fit on to the facts. For, as we have seen from the *St George* example, its tactic is to take some representational property that we ascribe to a work of art and then point out that there is some property that the relevant physical object possesses and that is incompatible with it, e.g. 'being instinct with life' and 'being inanimate'. But if we consider how, in point of fact, we do talk or think of works of representational art, we see that by and large what we ascribe representational properties to are elements or bits of the picture: it is only peripherally that we make such an attribution to the work itself, to the work, that is, as a whole.

Let us take, for instance, the justly famous descriptions given by Wölfflin of Raphael's Stanze in *Classic Art*: in particular, that of the *Expulsion of Heliodorus*. Wölfflin is generally thought of as a formalist critic. But if he is, it is

in a very restricted sense: since, even when he is most assiduous in using the vocabulary of geometry to describe compositional devices, it is significant how he identifies the shapes or forms whose arrangements he analyses. He does so invariably by reference back to the characters or happenings that they depict. When, as in the Raphael descriptions, his aim is to bring out the dramatic content of a painting, he keeps extremely close to its representational aspect. What in such circumstances do we find him mentioning? The movement of the youths: the fallen Heliodorus, with vengeance breaking over him: the women and the children huddled together: the clambering pair of boys on the left who balance the prostrate Heliodorus on the right, and who lead the eyes backward to the centre where the High Priest is praying. Now all these particular elements, which seem the natural items of discourse in the description of a representational painting – or better, perhaps, of a painting in its representational function – provide no obvious point of application for the argument under consideration. For there would have to be, corresponding to each of these elements, a physical object such that we could then ask of it whether it possessed some property that is incompatible with the representational property we have ascribed to the element.

But, it will be objected, I have not given the situation in full. For even in the description of the *Expulsion of Heliodorus*, there are nonparticular or over-all representational attributions. Wölfflin, for instance, speaks of 'a great void' in the middle of the composition.

This is true. But it looks as though the argument requires more than this. It requires not just that there should exist such attributions but that they should be central to the notion of representation: that, for instance,

it should be through them that we learn what it is for something to be a representation of something else. I want to argue that, on the contrary, they are peripheral. First, in a weaker sense, in that they have no priority over the more particular or specific attributions. The very general attributions come out of a very large range of attributions, and it certainly does not look as though we could understand them without understanding the other judgements in the range. It is hard to see, for instance, how a man could 'read' the void in the middle of Raphael's fresco if he was not at the same time able to make out the spatial relations that hold between Heliodorus and the youths who advance to scourge him, or between the Pope and the scene that he surveys in calm detachment. Secondly, a stronger argument could be mounted – though it would be too elaborate to do so here – to show that the representational attribution that we make in respect of the picture as a whole is dependent upon, or can be analysed in terms of, the specific attributions. The clearest way of exhibiting this would be to take simpler over-all attributions than Wölfflin's: for instance, that a picture has depth, or that it has great movement, or that it has a diagonal recession: and then show how these can be fully elucidated by reference to the spatial relations that hold between e.g. a tree in the foreground and the horizon, or the body of the saint and the crowd of angels through whom he ascends to heaven. A more dramatic way of exhibiting this would be to point out that we could not produce a sheet of blank paper and say that it was a representation of Empty Space. Though, of course, what we could do is to produce such a sheet and entitle it 'Empty Space', and there could be a point to this title.

12

Reference was made in the last section to the wide range of representational attributions that we make, and it is important to appreciate quite how wide it is. It certainly extends well beyond the domain of purely figurative art, and takes in such things as geometrical drawings or certain forms of architectural ornament. And I now suggest that if we look at the opposite end of this range to that occupied by, e.g. Raphael's Stanze, we may see our present problem in a fresh light.

It is said that Hans Hofmann, the doyen of New York painting, used to ask his pupils, on joining his studio, to put a black mark on a white canvas, and then observe how the black was on the white. It is clear that what Hofmann's pupils were asked to observe was not the fact that some black paint was physically on a white canvas. So I shall change the example somewhat to bring this out better, and assume that the young painters were asked to put a blue mark on a white canvas and then observe how the blue was behind (as it was) the white. The sense in which 'on' was used in the original example and 'behind' in the revised example give us in an elementary form the notion of what it is to see something as a representation, or for something to have representational properties. Accordingly, if we are going to accept the argument that works of art cannot be physical objects because they have representational properties, it looks as though we are committed to regarding the invitation to see the blue behind the white as something in the nature of an incitement to deny the physicality of the canvas. (This is imprecise: but the preceding section will have shown us how difficult it is to apply the argument we are considering with anything like precision.)

If it can be shown that it is quite wrong to treat the invitation in this way, that, on the contrary, there is no incompatibility between seeing one mark on the canvas as behind another and also insisting that both the marks and the canvas on which they lie are physical objects, then the present objection to the physical-object hypothesis fails. To establish this point would, however, require an elaborate argument. It might, though, be possible to avoid the need for such an argument by showing just how widespread or pervasive is the kind of seeing (let us call it 'representational seeing'), to which Hofmann's pupils were invited. In fact, it would be little exaggeration to say that such seeing is co-extensive with our seeing of any physical object whose surface exhibits any substantial degree of differentiation. Once we allow this fact, it then surely seems absurd to insist that representational seeing, and the judgements to which it characteristically gives rise, implicitly presuppose a denial of the physicality both of the representation itself and that on which it lies.

In a famous passage in the *Trattato* Leonardo advises the aspirant painter to 'quicken the spirit of invention' by looking at walls stained with damp or at stones of uneven colour, and find in them divine landscapes and battle scenes and strange figures in violent action. This passage has many applications both for the psychology and for the philosophy of art. Here I quote it for the testimony it provides to the pervasiveness of representational seeing.

13

In the preceding sections I have very closely associated the notion of representation with that of seeing-as, or, as I have called it, 'representational seeing': to the point of

suggesting that the former notion could be elucidated in terms of the latter. In this section I want to justify this association. But first, a word about the two terms between which the association holds.

'Representation', I have made clear, I am using in an extended sense: so that, for instance, the figure that occurs, in an ordinary textbook of geometry, at the head of Theorem XI of Euclid could be described as a configuration of intersecting lines, but it could also be thought of as a representation of a triangle. By contrast, I use the phrase 'seeing as' narrowly: uniquely, in the context of representation. In other words, I want to exclude from discussion here such miscellaneous cases as when we see the moon as no bigger than a sixpence, or the Queen of Hearts as the Queen of Diamonds, or (like the young Schiller) the Apollo Belvedere as belonging to the same style as the Laocoon of Rhodes: even though these cases are, I am sure, and could on analysis be shown to be, continuous with those I wish to consider.

With these points clear, I now return to the elucidation of representation in terms of seeing-as. I can foresee two objections: one, roughly, to the effect that this elucidation is more complex than it need be, the other to the effect that it is an oversimplification of the matter.

It might be argued that if, say, we are shown a representation of Napoleon, of course we will see it as Napoleon. But it would be oblique to invoke this second fact, which is really only a contingent consequence of the first fact, as an explanation of it: particularly when there is a more direct explanation to hand. For the fundamental explanation of why one thing is a representation of something else lies in the simple fact of resemblance: a picture or drawing is a representation of Napoleon because it resembles Napoleon – and it is for this reason too that we

come to see it as Napoleon (if, that is, we do) and not, as the argument of this essay would have it, vice versa.

But this more direct account of what it is for one thing to represent, or be of, another thing will not do: at any rate, as soon as we move beyond the simplest cases, like the diagrams in a geometry book. For the concept of resemblance is notoriously elliptical, or, at any rate, context-dependent: and it is hard to see how the resemblance that holds between a painting or a drawing and that which it is of would be apparent, or could even be pointed out, to someone who was totally ignorant of the institution or practice of representation.

Sometimes, it is true, we exclaim of a drawing, 'But how exactly like A!' But this is not the counterexample to my argument that it might at first seem to be. For if we try to expand the 'this', of which in such cases we predicate the resemblance, we are likely to find ourselves much closer to 'This *person* is exactly like A', than to 'This *configuration* is exactly like A'. In other words, the attribution of resemblance occurs inside, and therefore cannot be used to explain, the language of representation. This point receives further confirmation from the fact that, though the relation of resemblance is ordinarily held to be symmetrical, we can say apropos of a drawing, 'This is like Napoleon', but we cannot say, except in a special setting, 'Napoleon is exactly like this drawing' or 'Napoleon resembles this drawing': which seems to throw some light on how the 'this' in the first sentence is to be taken.

A second objection might run that my account of representation, so far from being overelaborate, is in fact sparser than the matter requires. For I omit one vital element: namely, the intention on the part of the person who makes the representation. It is necessary, if a draw-

ing is to represent Napoleon, that the draughtsman should intend it to be of Napoleon: furthermore, if he intends it to be of Napoleon, this suffices for it to be of Napoleon.

Now, the notion of intention has most obviously an important part to play in any complete analysis of representation: and if I have so far omitted it, this is because I have not been aiming at a complete analysis – nor, indeed, at one fuller than my immediate purposes require. If it were maintained that intention was a necessary, or even a sufficient, condition of representation, I do not know that I would object. This admission, however, does not make the radical difference it might initially seem to. More specifically, I would argue that it does not dispossess the notion of seeing-as from the position that I have assigned to it in the analysis of representation.

It is indeed only on one, and a quite erroneous, conception of what an intention is that the introduction of it into the analysis of representation could be thought to be radical in its implications. According to this conception, an intention is, or is identified with, a thought accompanying (or immediately preceding) an action and to the effect that 'I am now doing (or am about to do) such and such . . .': where, moreover, there is no restraint placed upon the kind of intention that the agent may attribute to himself, by what in point of fact he is doing. What the man is actually doing in no way curbs what he may say he is doing. It is not hard to see that, if we accept such a conception of intention, what we are disposed to see the drawing as, or how we see the drawing, becomes totally irrelevant to what the drawing is a representation of. For if the intention is irrespective of what the man is doing, it must *a fortiori* be irrespective of how we see what he has done when he has finished.

But though the correspondence between intention and action need not be exact (a man may intend to do something other than what he does), we cannot plausibly allow a relation of total fortuitousness to hold between them. If, for instance, a man drew a hexagon and simultaneously thought to himself, 'I am going to draw Napoleon', we might maintain that this thought showed something about him but it clearly would show nothing about what he intended to draw there and then. The general question of what makes an accompanying thought an intention is very complex: but in the area that concerns us, that of representation, it would certainly seem that whether a thought does express the intention behind that act of, say, drawing which it accompanies is not independent of what the result of the action, in this case the drawing itself, can be seen as. And this supposition is further confirmed by the fact that we could not imagine a man forming any intention at all to represent something, unless he could also anticipate how the drawing would look. If this is correct, then obviously the introduction of the notion of intention into an analysis of representation, which had so far been carried out uniquely by reference to seeing-as, will not subvert the analysis; since intention is itself intimately connected with seeing-as. The intention, we might say, looks forward to the representational seeing.

I have stated, and argued against, two objections to my view that there is an intrinsic relation between representation and seeing-as. But I have said nothing in favour of the view. I believe, however, that once the objections have been met, the obvious appeal of my view will assert itself: the appeal resting, I suppose, upon some rather banal but undeniable fact such that a representation of something is a visual sign, or reminder, of it.

I hope it is clear that I have said nothing to cast doubt on the fact that what counts as a representation of what, or how we represent things, is a culturally determined matter.

14

I have (it will be observed) presented the problem about representational properties and the *prima facie* difficulty they present for the physical-object hypothesis as though this was a problem that arose, at any rate in the first instance, only in connexion with certain representational properties. There are, that is, cases where we attribute a representational property to a work of art and this clearly conflicts with some other property or properties that the corresponding physical object possesses. So, for instance, we say that a still-life has depth, but the canvas is flat; that a fresco has a void in the middle, but the wall on which it is painted is intact. And it is only where such a conflict occurs that, as I presented it, a problem occurs. It was for this reason that I amended the Hofmann case to that of a master who asked his students to put (blue) paint *on* the (white) canvas in such a way that they saw the blue (= colour of the paint) *behind* the white (= colour of the canvas). For though, of course, conflicts could arise if one pursued the original Hofmann case any distance (e.g. if someone asked, How far is the black in front of the white?), in the amended case the conflict arises immediately.

In presenting the problem thus, I coincided, I think, with the way it is generally conceived. In other words, representational properties are not regarded as being in general problematic. However, when we turn from the problem of representational properties to that of express- ive properties and how they bear on the identification of

works of art with physical objects, the situation some-what changes. For the problem seems to be not, How can a work of art qua physical object of this or that kind express this or that emotion? but, How can a work of art qua physical object express emotion?

(Of course, there is a problem, which has indeed been much discussed recently, and which we shall deal with later [sections 28–31], about how a particular work of art can express a particular emotion. But that problem, it is important to see, is not our present problem. It has nothing to do with the identity of physical objects and works of art; it arises whatever view we take on that issue.)

If I am right in asserting the difference between the ways in which representational and expressive properties prove problematic – and I have no desire to be insistent here – the explanation may well lie in the fact that, though there is nothing other than a physical object that has representational properties, there is something other than a physical, or at any rate a purely physical, object that has expressive properties: namely, a human body and its parts, in particular the face and certain limbs. So now we wonder, How can anything other than this be expressive? More specifically, How can anything purely physical be expressive?

15

We might begin by considering two false views of how works of art acquire their expressiveness: not simply so as to put them behind us, but because each is in its way a pointer to the truth. Neither view requires us to suppose that works of art are anything other than physical objects.

The first view is that works of art are expressive be-

cause they have been produced in a certain state of mind or feeling on the part of the artist: and to this the rider is often attached, that it is this mental or emotional condition that they express. But if we take the view first of all with the rider attached, its falsehood is apparent. For it is a common happening that a painter or sculptor modifies or even rejects a work of his because he finds that it fails to correspond to what he experienced at the time. If, however, we drop the rider, the view now seems arbitrary or perhaps incomplete. For there seems to be no reason why a work should be expressive simply because it was produced in some heightened condition if it is also admitted that the work and the condition need not have the same character. (It would be like trying to explain why a man who has measles is ill by citing the fact that he was in contact with someone else who was also ill when that other person was not ill with measles or anything related to measles.) It must be understood that I am not criticizing the view because it allows an artist to express in his work a condition other than that which he was in at the time: my case is rather that the view does wrong both to allow this fact and to insist that the expressiveness of the work can be accounted for exclusively in terms of the artist's condition.

However, what is probably the more fundamental objection to this view, and is the point that has been emphasized by many recent philosophers, is that the work's expressiveness now becomes a purely external feature of it. It is no longer something that we can or might observe, it is something that we infer from what we observe: it has been detached from the object as it manifests itself to us, and placed in its history, so that it now belongs more to the biography of the artist than to criticism of the work. And this seems wrong. For the

qualities of gravity, sweetness, fear, that we invoke in describing works of art seem essential to our understanding of them; and if they are, they cannot be extrinsic to the works themselves. They cannot be, that is, mere attributes of the experiences or activities of Masaccio, of Raphael, of Grünewald – they inhere rather in the Brancacci frescoes, in the Granduca Madonna, in the Isenheim Altarpiece.

The second view is that works of art are expressive because they produce or are able to produce a certain state of mind or feeling in the spectator: moreover (and in the case of this view it is difficult to imagine the rider ever detached), it is this mental or emotional condition that they express. This view is open to objections that closely parallel those we have just considered.

For, in the first place, it seems clearly false. Before works even of the most extreme emotional intensity, like Bernini's St Teresa or the black paintings of Goya, it is possible to remain more or less unexcited to the emotion that it would be agreed they express. Indeed, there are many theories that make it a distinguishing or defining feature of art that it should be viewed with detachment, that there should be a distancing on the part of the spectator between what the work expresses and what he experiences: although it is worth noting, in passing, that those theorists who have been most certain that works of art do not arouse emotion, have also been uncertain, in some cases confused, as to how this comes about: sometimes attributing it to the artist, sometimes to the spectator; sometimes, that is, saying that the artist refrains from giving the work the necessary causal power, sometimes saying that the spectator holds himself back from reacting to this power.

However, the main objection to this view, as to the

previous one, is that it removes what we ordinarily think of as one of the essential characteristics of the work of art from among its manifest properties, locating it this time not in its past but in its hidden or dispositional endowment. And if it is now argued that this is a very pertinent difference, in that the latter is, in principle at least, susceptible to our personal verification in a way in which the former never could be, this misses the point. Certainly we can actualize the disposition, by bringing it about that the work produces in us the condition it is supposed to express: and there is clearly no corresponding way in which we can actualize the past. But though this is so, this still does not make the disposition itself – and it is with this, after all, that the work's expressiveness is equated – any the more a property that we can observe.

16

And yet there seems to be something to both these views: as an examination of some hypothetical cases might bring out.

For let us imagine that we are presented with a physical object – we shall not for the moment assume that it either is or is supposed to be a work of art – and the claim is made on its behalf, in a way that commands our serious attention, that it is expressive of a certain emotion: say, grief. We then learn that it had been produced quite casually, as a diversion or as a part of a game: and we must further suppose that it arouses neither in us or in anyone else anything more than mild pleasure. Can we, in the light of these facts, accept the claim? It is conceivable that we might; having certain special reasons.

But now let us imagine that the claim is made on

behalf not of a single or isolated object, but of a whole class of objects of which our original example would be a fair specimen, and it turns out that what was true of it is true of all of them both as to how they were produced and as to what they produce in us. Surely it is impossible to imagine any circumstances in which we would allow *this* claim.

But what are we to conclude from this? Are we to say that the two views are true in a general way, and that error arises only when we think of them as applying in each and every case? The argument appears to point in this direction, but at the same time it seems an unsatisfactory state in which to leave the matter. (Certain contemporary moral philosophers, it is true, seem to find a parallel situation in their own area perfectly congenial, when they say that an individual action can be right even though it does not satisfy the utilitarian criterion, provided that that sort of action, or that that action in general, satisfies the criterion: the utilitarian criterion, in other words, applies on the whole, though not in each and every case.)

The difficulty here is this: Suppose we relax the necessary condition in the particular case because it is satisfied in general, with what right do we continue to regard the condition that is satisfied in general as necessary? Ordinarily the argument for regarding a condition as necessary is that there could not be, or at any rate is not, anything of the requisite kind that does not satisfy it. But this argument is not open to us here. Accordingly, at the lowest, we must be prepared to give some account of how the exceptions arise: or, alternatively, why we are so insistent on the condition in general. To return to the example: it seems unacceptable to say that a single object can express grief though it was not produced in, nor is it

productive of, that emotion, but that a class of objects cannot express grief unless most of them, or some of them, or a fair sample of them, satisfy these conditions – unless we can explain why we discriminate in this way.

At this point what we might do is to turn back and look at the special reasons, as I called them, which we might have for allowing an individual object to be expressive of grief though it did not satisfy the conditions that hold generally. There seem to be roughly two lines of thought which if followed might allow us to concede expressiveness. We might think, 'Though the person who made this object didn't feel grief when he made it, yet this is the sort of thing I would make if I felt grief. . . .' Alternatively we might think, 'Though I don't feel grief when I look at this here and now, yet I am sure that in other circumstances I would. . . .' Now, if I am right in thinking that these are the relevant considerations, we can begin to see some reason for our discrimination between the particular and the general case. For there is an evident difficulty in seeing how these considerations could apply to a whole class of objects: given, that is, that the class is reasonably large. For our confidence that a certain kind of object was what we would produce if we experienced grief would be shaken by the fact that not one (or very few) had actually been produced in grief: equally, our confidence that in other circumstances we should feel grief in looking at them could hardly survive the fact that no one (or scarcely anyone) ever had. The special reasons no longer operating, the necessary conditions reassert themselves.

17

However, the foregoing argument must not be taken as simply reinstating the two views about the nature of expression which were introduced and criticized in section 15. That would be a misinterpretation: though one which the argument as it has been presented might be thought to invite.

It is true that both – that is, both the new argument and the old views – make reference to the same criteria of expressiveness: the psychic state on the one hand of the artist, on the other hand of the spectator. But the use they make of these criteria is very different in the two cases. In the one case the criteria are asserted categorically, in the other at best hypothetically. Originally it was claimed that works of art were expressive of a certain state if and only if they had been produced in, and were capable of arousing to, that state. Now this claim has been dropped, and the link that is postulated between, on the one hand, the work and, on the other hand, the psychic state of either artist or spectator holds only via a supposition: 'If I were in that state ...', 'If I were in other circumstances. ...'

There are, however, two ways in which the gap between the old and the new version of the matter can be narrowed, even if it cannot (indeed it cannot) be closed. The first is by the introduction of unconscious feelings. The second is by a more generous conception of the different relations in which a person can stand to the conscious feelings that he has. For it is a fact of human nature, which must be taken into account in any philosophical analysis of the mind, that, even when feelings enter into consciousness, they can be comparatively split off or dissociated: the dissociation sometimes occurring in

accordance with the demands of reality, as in memory or contemplation, or sometimes in more pathological ways.

Now it is clear that much of the crudity – and for that matter of the vulnerability – of the two original views of expression came from overlooking or ignoring these two factors. So, for instance, the claim that certain music is sad because of what the composer felt is sometimes equated – by its proponents as well as by its critics – with the claim that at the time the composer was suffering from a bout of gloom. Or, again, to say that a certain statue is terrifying because of the emotions it arouses in the spectators is sometimes interpreted as meaning that someone who looks at it will take fright. In other words, to establish that the composer was not on the verge of tears or that the average spectator exhibits no desire to run away, is thought to be enough to refute this whole conception of expression. But there are feelings that a man has of which he is not conscious, and there are ways of being in touch with those which he has other than experiencing them in a primary sense: and a more real-istic statement of the two original views should not require more than that the state expressed by the work of art is among those states, conscious or unconscious, to which the artist and the spectator stand in some pos-sessive relation.

Such a restatement would not merely add to the realism of these new views: it would also bring them ap-preciably closer to the new account which we have sub-stituted for them. For as long as we confine ourselves to conscious feelings or feelings which we experience pri-marily, there is obviously a substantial gap between the supposition that something or other is what we would have felt if we had made a certain object, and the as-

sertion that this is what the person who made it felt: and, again, between the supposition that we would feel in such and such a way before a certain object in other circumstances, and the assertion that this is what we really feel before it. But enlarge the conception of human feelings, extend it so as to take in the whole range of psychic states, and the situation considerably changes. There is still, of course, a gap, but the gap has so shrunk that it is sometimes thought to be no wider than can be crossed by the leap from evidence to conclusion. In other words, a speculation about what I would have felt in someone else's situation or in other circumstances can, in favoured conditions, be warrant enough for an assertion about what that person really feels or about our own hidden emotions.

18

The question, however, might now be raised, Suppose the two criteria, which hitherto have been taken so closely together, should diverge: for they might: how could we settle the issue? And the difficulty here is not just that there is no simple answer to the question, but that it looks as though any answer given to it would be arbitrary. Does this, therefore, mean that the two criteria are quite independent, and that the whole concept of expression, if, that is, it is constituted as I have suggested, is a contingent conjunction of two elements, which could as easily fall apart as together?

I shall argue that the concept of expression, at any rate as this applies to the arts, is indeed complex, in that it lies at the intersection of two constituent notions of expression. We can gain some guidance as to these notions from the two views of expression we have been considering, for they are both reflected in, though also dis-

torted by, these views. But, whereas the two views seem quite contingently connected, and have no clear point of union, once we understand what these notions are we can see how and why they interact. Through them we can gain a better insight into the concept of expression as a whole.

In the first place, and perhaps most primitively, we think of a work of art as expressive in the sense in which a gesture or a cry would be expressive: that is to say, we conceive of it as coming so directly and immediately out of some particular emotional or mental state that it bears unmistakable marks of that state upon it. In this sense the word remains very close to its etymology: *exprimere*, to squeeze out or press out. An expression is a secretion of an inner state. I shall refer to this as 'natural expression'. Alongside this notion is another, which we apply when we think of an object as expressive of a certain condition because, when we are in that condition, it seems to us to match, or correspond with, what we experience inwardly: and perhaps when the condition passes, the object is also good for reminding us of it in some special poignant way, or for reviving it for us. For an object to be expressive in this sense, there is no requirement that it should originate in the condition that it expresses, nor indeed is there any stipulation about its genesis: for these purposes it is simply a piece of the environment which we appropriate on account of the way it seems to reiterate something in us. Expression in this sense I shall (following a famous nineteenth-century usage) call 'correspondence'.

We may now link this with the preceding discussion by saying that the preoccupation with what the artist felt, or might have felt, reflects a concern with the work of art as a piece of natural expression: whereas the pre-

occupation with what the spectator feels, or might feel, reflects a concern with the work of art as an example of correspondence.

But though these two notions are logically distinct, in practice they are bound to interact: indeed, it is arguable that it goes beyond the limit of legitimate abstraction to imagine one without the other. We can see this by considering the notion of appropriateness, or fittingness, conceived as a relation holding between expression and expressed. We might think that such a relation has a place only in connexion with correspondences. For in the case of natural expression, the link between inner and outer is surely too powerful or too intimate to allow its mediation. It is not because tears seem like grief that we regard them as an expression of grief: nor does a man when he resorts to tears do so because they match his condition. So we might think. But in reality, at any level above the most primitive, natural expression will always be coloured or influenced by some sense of what is appropriate; there will be a feedback from judgement, however inchoate or unconscious this may be, to gesture or exclamation. Again, when we turn to correspondence, it might seem that here we are guided entirely by appropriateness or the fit: that is to say, we appeal uniquely to the appearances or characteristics of objects, which hold for us, in some quite unanalysed way, an emotional significance. We do not (we might think) check these reactions against observed correlations. But once again this is a simplification. Apart from a few primitive cases, no physiognomic perception will be independent of what is for us the supreme example of the relationship between inner and outer: that is, the human body as the expression of the psyche. When we endow a natural object or an artifact with expressive meaning, we tend to see it

corporeally: that is, we tend to credit it with a particular look which bears a marked analogy to some look that the human body wears and that is constantly conjoined with an inner state.

19

To the question, Can a work of art be a physical object if it is also expressive?, it now looks as though we can, on the basis of the preceding account of expression, give an affirmative answer. For that account was elaborated with specifically in mind those arts where it is most plausible to think of a work of art as a physical object. But it may seem that with both the two notions of expression that I have tried to formulate, there remains an unexamined or problematic residue. And in the two cases the problem is much the same.

It may be stated like this: Granted that in each case the process I have described is perfectly comprehensible, how do we come at the end of it to attribute a human emotion to an object? In both cases the object has certain characteristics. In one case these characteristics mirror, in the other case they are caused by, certain inner states of ours. Why, on the basis of this, do the names of the inner states get transposed to the objects?

The difficulty with this objection might be put by saying that it treats a philosophical reconstruction of a part of our language as though it were a historical account. For it is not at all clear that, in the cases where we attribute emotions to objects in the ways that I have tried to describe, we have any other way of talking about the objects themselves. There is not necessarily a prior description in non-emotive terms, on which we superimpose the emotive description. Or, to put the same point in nonlinguistic terms, it is not always the case that

things that we see as expressive, we can or could see in any other way. In such cases what we need is not a justification, but an explanation, of our language. That I hope to have given.

20

We have now completed our discussion of the physical-object hypothesis, and this would be a good moment at which to pause and review the situation.

The hypothesis, taken literally, has been clearly shown to be false: in that there are arts where it is impossible to find physical objects that are even candidates for being identified with works of art (sections 6–8). However, as far as those other arts are concerned where such physical objects can be found, the arguments against the identification – namely, those based on the fact that works of art have properties not predicable of physical objects – seemed less cogent (sections 9–19). I have now to justify the assertion that I made at the very beginning of the discussion (section 5) that it was only in so far as it related to these latter arts that the challenge to this hypothesis had any fundamental significance for aesthetics.

The general issue raised, whether works of art are physical objects, seems to compress two questions: the difference between which can be brought out by accenting first one, then the other, constituent word in the operative phrase. Are works of art *physical* objects? Are works of art physical *objects*? The first question would be a question about the stuff or constitution of works of art, what in the broadest sense they are made of: more specifically, Are they mental? or physical? are they constructs of the mind? The second question would be a question about the category to which works of art belong, about the criteria of identity and individuation appli-

cable to them: more specifically. Are they universals, of which there are instances?, or classes, of which there are members?, are they particulars? Roughly speaking, the first question might be regarded as metaphysical, the second as logical and, confusingly enough, both can be put in the form of a question about what kind of thing a work of art is.

Applying this distinction to the preceding discussion, we can now see that the method of falsifying the hypothesis that all works of art are physical objects has been to establish that there are some works of art that are not objects (or particulars) at all: whereas the further part of the case which depends upon establishing that those works of art which are objects are nevertheless not physical has not been made good. If my original assertion is to be vindicated, I am now required to show that what is of moment in aesthetics is the physicality of works of art rather than their particularity,

21

If a work of art is held to be a particular but not physical, the next step is to posit a further object, over and above the relevant physical object, and this object is then regarded as the work of art. Nonphysical itself, this object nevertheless stands in a very special relation to the physical object that (as we might say) would have been the work of art if works of art had been or could be, physical. Of the nature of this object, there are, broadly speaking, two different theoretical accounts.

According to one kind of theory the work of art is nonphysical in that it is something mental or even ethereal: its location is in the mind or some other spiritual field, at any rate in a region uninhabited by physical bodies: hence we do not have direct sensible access to it, though

presumably we are able to infer it or intuit it or imaginatively re-create it from the object in the world that is its trace or embodiment. According to the other kind of theory, the work of art differs from physical objects, not in the sense that it is imperceptible, but because it has only sensible properties: it has no properties (for instance, dispositional or historical) that are not open to direct or immediate observation. Whether on this account we are to regard works of art as public or private depends upon what view we take of the nature of sensory fields, which is now their location.

In denying that works of art are physical objects, the first kind of theory withdraws them altogether from experience, whereas the second kind pins them to it inescapably and at all points. I shall speak of the first as making out of works of art 'ideal' objects, and of the second as making out of them 'phenomenal' or 'presentational' objects. I have now to establish that both theories, the Ideal and the Presentational, involve fundamental distortions in their account of what art is.

22

Let us begin with the Ideal theory. It is usual nowadays to think of this as the Croce–Collingwood theory, and to consider it in the extended form that it has been given by these two philosophers, who, moreover, differ only in points of detail or emphasis. I shall follow this practice, though (as elsewhere) recasting the original arguments where the requirements of this essay necessitate.

The Ideal theory can be stated in three propositions. First, that the work of art consists in an inner state or condition of the artist, called an intuition or an expression: secondly, that this state is not immediate or given, but is the product of a process, which is peculiar to

the artist, and which involves articulation, organization, and unification: thirdly, that the intuition so developed may be externalized in a public form, in which case we have the artifact which is often but wrongly taken to be the work of art, but equally it need not be.

The origin of this theory, which we should understand before embarking upon criticism, lies in taking seriously the question, What is distinctive – or perhaps better, What is distinctively 'art' – in a work of art?, and giving it an answer that has both a positive and a negative aspect.

In his *Encyclopaedia Britannica* article on 'Aesthetics', Croce asks us to consider, as an example of both familiar and high art, the description given by Virgil of Aeneas's meeting with Andromache by the waters of the river Simois (*Aeneid*, III, lines 294 ff.). The poetry here, he suggests, cannot consist in any of the details that the passage contains – the woes and shame of Andromache, the overcoming of misfortune, the many sad aftermaths of war and defeat – for these things could equally occur in works of history or criticism, and therefore must be in themselves 'nonpoetic': what we must do is to look beyond them to that which makes poetry out of them, and so we are led of necessity to a human experience. And what is true of poetry is true of all the other arts. In order to reach the distinctively aesthetic, we must ignore the surface elements, which can equally be found in non-artistic or practical contexts, and go straight to the mind, which organizes them. Having in this way identified the work of art with an inner process, can we say anything more about this process?

It is at this point that the negative aspect of the theory takes over. What the artist characteristically does is best understood by contrast with – and this is perhaps Col-

lingwood more than Croce – what the craftsman charac-
teristically does. Since what is characteristic of the
craftsman is the making of an artifact, or 'fabrication',
we can be certain that the artist's form of making, or
'creation', is not this kind of thing at all.

The contrast between art and craft, which is central to
Collingwood's *Principles of Art*, would appear to rest
upon three distinctive characteristics of craft. First, every
craft involves the notion of a means and an end, each
distinctly conceived, the end being definitive of the par-
ticular craft, and the means whatever is employed to
reach that end; secondly, every craft involves the dis-
tinction between planning and execution, where plan-
ning consists in foreknowledge of the desired result and
calculation as to how best to achieve this, and the ex-
ecution is the carrying out of this plan; finally, every
craft presupposes a material upon which it is exercised
and which it thereby transforms into something different.
None of these characteristics, the theory argues, pertains
to art.

That art does not have an end is established, it might
seem, rather speciously by rebutting those theories which
propose for art some obviously extrinsic aim like the
arousing of emotion, or the stimulation of the intellect, or
the encouragement of some practical activity: for these
aims give rise to amusement, magic, propaganda, etc. But,
it might be urged, why should not the end of Art be, say,
just the production of an expressive object? To this one
reply would be that this would not be, in the appropriate
sense, a case of means and end, since the two would not
be conceived separately. Another and more damaging
reply would be that this would involve an assimilation of
art to craft in its second characteristic. The artist is now
thought of as working to a preconceived plan, or as

having foreknowledge of what he intends to produce; and this is impossible.

The trouble with this argument – like the more general epistemological argument, of which it can be regarded as a special instance, i.e., that present knowledge of future happenings *tout court* is impossible – is that it acquires plausibility just because we don't know what degree of specificity is supposed to be attributed to what is said to be impossible. If a very high degree of specificity is intended, the argument is obviously cogent. The artist could not know to the minutest detail what he will do. However, if we lower the degree of specificity, the artist surely can have foreknowledge. It is, for instance, neither false nor derogatory to say that there were many occasions on which Verdi knew that he was going to compose an opera, or Bonnard to make a picture of his model. And, after all, the craftsman's foreknowledge will often be no fuller.

That every craft has its raw material and art doesn't – the third criterion of the distinction – is argued for by showing that there is no uniform sense in which we can attribute to the arts a material upon which the artist works. There is nothing out of which the poet can be said to make his poem in the sense in which the sculptor can be said (though falsely, according to the theory) to make his sculpture out of stone or steel.

I now wish to turn to criticism of the Ideal theory. For it must be understood that nothing that has so far been produced has had the character of an argument against the theory. At most we have had arguments against arguments historically advanced in support of it.

23

There are two arguments that are widely advanced against the Ideal theory.

The first is that by making the work of art something inner or mental, the link between artist and audience has been severed. There is now no object to which both can have access, for no one but the artist can ever know what he has produced.

Against this it might be retorted that this extreme sceptical or solipsistic conclusion would follow only if it was maintained that works of art could never be externalized: whereas all the Ideal theory asserts is that they need not be. A parallel exists in the way in which we can know what a man is thinking, even though his thoughts are something private, for he might disclose his thoughts to us. This retort, it might be felt, while avoiding scepticism, still leaves us too close to it for comfort. Even Collingwood, for instance, who was anxious to avoid the sceptical consequences of his theory, had to concede that on it the spectator can have only an 'empirical' or 'relative' assurance about the artist's imaginative experience, which, of course, just is, for Collingwood, the work of art. This seems quite at variance with our ordinary – and equally, as I hope to show, with our reflective – views about the public character of art.

The second argument is that the Ideal theory totally ignores the significance of the medium: it is a characteristic fact about works of art that they are in a medium, whereas the entities posited by the Ideal theory are free or unmediated. A first reaction to this argument might be to say that it is an exaggeration. At the lowest we need to make a distinction within the arts. In literature and music we can surely suppose a work of art to be complete

before it is externalized without this having any negative implications for the medium. A poem or an aria could exist in the artist's head before it is written down: and although difficulties may exist in the case of a novel or an opera, we can conceive adjustments of mere detail in the theory that would accommodate them. But does this preserve the theory, even in this area? For, if the occurrence of certain experiences (say, the saying of words to oneself) justifies us in postulating the existence of a certain poem, this is not to say that the poem is those experiences. A fairer (though certainly not a clear) way of putting the matter would be to say that it is the object of those experiences. And the object of an experience need not be anything inner or mental.

Anyhow these cases should not preoccupy us. For (to return to the starting point of this whole discussion) it is not works of art of these kinds that provide crucial tests for the Ideal theory. What that theory has primarily to account for are those works of art which are particulars. The question therefore arises, If we are asked to think of, say, paintings and sculptures as intuitions existing in the artist's mind, which are only contingently externalized, is this compatible with the fact that such works are intrinsically in a medium?

An attempt has been made to defend the theory at this stage by appeal to a distinction between the 'physical medium' and the 'conceived medium': the physical medium being the stuff in the world, the conceived medium being the thought of this in the mind. The defence now consists in saying that the whole process of inner elaboration, on which the theory lays such weight and which Croce explicitly identifies with expression (*l'identità di intuizione ed espressione*), goes on in a medium in that it goes on in the conceived medium. So,

for instance, when Leonardo scandalized the prior of S. Maria delle Grazie by standing for days on end in front of the wall he was to paint, without touching it with his brush – an incident Croce quotes as evidence of this 'inner' process of expression – we may suppose that the thoughts that occupied his mind were of painted surface, were perhaps images of ever-developing articulation of what he was to set down. Thus a work of art was created that was both in an artist's mind and in a medium.

However, two difficulties still arise. The first concerns the nature of mental images. For it is hard to believe that mental images could be so articulated as in all respects to anticipate the physical pictures to be realized on wall or canvas. For this would involve not merely foreseeing, but also solving, all the problems that will arise, either necessarily or accidentally, in the working of the medium: and not merely is this implausible, but it is even arguable that the accreditation of certain material processes as the media of art is bound up with their inherent unpredictability: it is just because these materials present difficulties that can be dealt with only in the actual working of them that they are so suitable as expressive processes. Again – to borrow an argument from the philosophy of mind – is it even so clear what meaning we are to attach to the supposition that the image totally anticipates the picture? For unless the picture is one of minimal articulation, in which case we could have an image of the whole of it simultaneously, we will have to attribute to the image properties beyond those of which we are aware. But this, except in marginal cases, is objectionable: for by what right do we determine what these extra properties are? (Sartre has made this point by talking of the image's 'essential poverty'.)

A second difficulty is this: that if we do allow that the

inner process is in a conceived medium, this seems to challenge the alleged primacy of the mental experience over the physical artifact, on which the Ideal theory is so insistent. For now the experience seems to derive its content from the nature of the artifact: it is because the artifact is of such and such a material that the image is in such and such a conceived medium. The problem why certain apparently arbitrarily identified stuffs or processes should be the vehicles of art – what I shall call the *bricoleur* problem, from the striking comparison made by Lévi-Strauss of human culture to a *bricoleur* or handiman, who improvises only partly useful objects out of old junk – is a very real one: but the answer to it cannot be that these are just the stuffs or processes that artists happen to think about or conceive in the mind. It is more plausible to believe that the painter thinks in images of paint or the sculptor in images of metal just because these, independently, are the media of art: his thinking presupposes that certain activities in the external world such as charging canvas with paint or welding have already become the accredited processes of art. In other words, there could not be Crocean 'intuitions' unless there were, first, physical works of art.

24

However, of the two theories that set out to account for works of art on the assumption that they cannot be physical objects, it is the Presentational theory that is more likely to be found acceptable nowadays: if only because the account it gives is less recondite.

Of the Ideal theory it might be said that its particular character derives from the way it concentrates exclusively upon one aspect of the aesthetic situation: the process, that is, of artistic creation. The Presentational

theory feeds on no less one-sided a diet: in its case, it is the situation of the spectator, or perhaps more specifically that of the critic, that comes to dominate the account it provides of what a work of art is. It might seem a tautology that all that the spectator of a work of art has to rely upon (qua spectator, that is) is the evidence of his eyes or ears, but it goes beyond this to assert that this is all that the critic can, or qua critic should, rely upon, and this further assertion is justified by an appeal to the 'autonomy of criticism'. The idea is that, as soon as we invoke evidence about the biography or the personality of the artist or the prevailing culture or the stylistic situation, then we have deviated from what is given in the work of art and have adulterated criticism with history, psychology, sociology, etc. (To trace the two theories in this way to preoccupations with differing aspects of the aesthetic situation is not, of course, to say that either theory gives a correct account of that particular aspect with which it is preoccupied, nor for that matter is it to concede that the two preoccupations can be adequately pursued in isolation or abstraction one from the other.)

The theory before us is that a work of art possesses those properties, and only those, which we can directly perceive or which are immediately given. As such the theory seems to invite criticism on two levels. In the first place (it may be argued), the distinction upon which it rests – namely, that between properties that we immediately perceive and those which are mediately perceived or inferred – is not one that can be made in a clear – or, in some areas, even in an approximate – fashion. Secondly, where the distinction can be made, it is wrong to deny to the work of art everything except what is immediately perceptible: what ensues is a diminished or depleted ver-

sion of art. I shall deal with the first kind of objection in sections 25–30, and the second kind in sections 32–4.

Contemporary theory of knowledge is full of arguments against the distinction enshrined in traditional empiricism between that which is, and that which is not, given in perception, and it would be inappropriate to rehearse these general arguments here. I shall, therefore, confine my examination of the distinction to two large classes of property, both of which we have already had to consider on the assumption that they are intrinsic to works of art, and which seem to offer a peculiarly high degree of resistance to the distinction: I refer to meaning, or semantic, properties, and expressive properties. If both these sets of properties really are intractably indeterminate as to this distinction, then it would follow that the Presentational theory, which presupposes the distinction, must be inadequate.

25

Let us begin with meaning-properties.

In the *Alciphron* (Fourth Dialogue) Berkeley argues that when we listen to a man speaking, the immediate objects of sense are certain sounds, from which we infer what he means. The claim might be put by saying that what we immediately hear are noises, not words, where words are something intrinsically meaningful. If we conjoin this claim to the Presentational theory, we arrive at the view that a poem is essentially concatenated noises: and this indeed is the view (and the argument) that, implicit in a great deal of Symbolist aesthetics, has found its most explicit formulation in the Abbé Bremond's doctrine of *poésie pure*. Without considering whether this is or is not an acceptable account of or programme for poetry, I want to examine one presupposition of it:

which is that we can (not, that we do, or, that we should) listen to words as pure sound.

There is one obvious argument in support of this: Imagine that we have a poem read out to us in a language we don't understand. In that case we must listen to it as pure sound: if, for instance, we admire the poem, we must admire it for its sound alone, for there is nothing else open to us to admire it for. If we can listen to a poem in an unknown language like that, we can presumably listen to a poem in any language in the same way.

But the argument lacks force. For there are many ways in which we can react to utterances we don't understand which would not be possible for us if we did understand them: for instance, we could sit utterly unangered through a string of wounding abuse in a language we didn't know. If it is now retorted that we could do the same even if we knew the language, provided that we didn't draw on this knowledge, this seems to beg the question: for it is very unclear what is meant by listening to a language we know without drawing on our knowledge except listening to it as pure sound. So there is no argument, only assertion.

A supplementary consideration is this: if we could hear an utterance that we understood as mere sound, then, on the proviso that we can reproduce it at all, we surely should be able to reproduce it by mimicry: that is, without reference to the sense, but aiming simply to match the original noises. Such a possibility would seem to be involved in the concept of hearing something as a sound. But to achieve such mimicry with a word we understand seems not merely factually impossible, but absurd.

Another kind of argument that might be invoked in support of the view that we can listen to poetry as pure

sound is that we often admire poetry for its aural proper-
ties. This is true. But when we come to investigate such
cases, they are quite evidently unable to sustain the kind
of interpretation that the argument would put on them.
What we find is a range of cases: at one end, where the
(so-called) aural properties of rhythm etc. are actually
identified by reference to the sense of the poetry, as in
Wyatt's sonnet 'I abide, and abide, and better abide'; at
the other end, where the aural properties can be
identified purely phonetically but they presuppose for
their effect (at the lowest) a noninterference by, or a
degree of collusion from, the sense, as in Poe's famous
line:

And the silken, sad, uncertain rustling of each purple curtain

or in much of Swinburne. It is an unwarranted extra-
polation beyond this second kind of case to the hypo-
thetical case where the aural properties of the poem can
be assessed in a way that is quite indifferent as to the
sense.

Of course, there is a certain amount of poetry where the
words are concatenated in accordance not with their
sense but purely with their sound. Some of Shakespeare's
songs are examples of this, some Rimbaud, some Smart,
most nonsense poetry or doggerel. But it does not follow
from the fact that the 'lyrical initiative' (the phrase is
Coleridge's) is sustained in this way, that we listen to the
poetry and ignore the sense. On the contrary: it would
seem that in such cases just the fact that the sense has
been sacrificed, or becomes fragmented, is something of
which we need to be aware, if we are to appreciate the
poem. Nonsense poetry is not the most accessible part of
a language's literature.

26

If we turn to the visual arts, the analogue to the meaning or semantic properties is the representational properties. The general question, whether these are directly perceptible, is beyond the scope of this essay. Certainly many philosophers have denied that they are: from which it would follow, in conjunction with the thesis that works of art are presentational, that, say, paintings in so far as they pertain to art represent nothing and their aesthetic content consists exclusively in flat coloured surfaces and their juxtapositions. Indeed, this is how a great deal of 'formalist' aesthetics is arrived at: and if in the actual criticism of such formalists we often encounter references to solid shapes, e.g. cubes, cylinders, spheres, as part of the painting's content, this seems to be inconsistency, since the only way in which volumes can inhere in a two-dimensional painting is through representation. On the other hand, Schopenhauer, who also held that works of art are essentially perceptual, argued that we look at a picture, e.g. Annibale Carracci's *Genius of Fame*, legitimately, or as we should, when we see in it a beautiful winged youth surrounded by beautiful boys, but illegitimately, i.e. we 'forsake the perception', when we look for its allegorical or merely 'nominal' significance. So for him, presumably, representational properties *were* directly perceptible.

In this section I shall confine myself to a part of the problem: namely, whether represented movement is directly perceptible, or whether movement can be depicted. This limited issue has, however, as well as its intrinsic, a great historical, interest. For it was a negative answer given to it that, combined with something like a presentational theory, generated one of the most power-

ful of traditional aesthetic doctrines i.e. the Shaftes-
bury–Lessing theory of 'the limits of poetry and
painting' (to quote the subtitle of the *Laocoon*). Lessing's
argument is, briefly, that painting, whose means, i.e.
figures and colours, co-exist in space, has as its proper
subject bodies: whereas poetry, whose means, i.e. sounds,
succeed one another in time, has as its proper subject
actions.

Now let us examine the issue itself. Imagine that we
are looking at Delacroix's *Combat du Giaour et du Pacha*.
What do we directly see? There is one obvious argument
in favour of saying that we don't (directly) perceive the
movement of the two horsemen, and that is, that what
we are looking at, i.e., a canvas on which the two horse-
men are represented, is not itself in movement. (This in
fact is Lessing's own argument.) But the principle on
which this argument is based is obviously unacceptable:
namely, that of determining the properties that we im-
mediately see by reference to the properties possessed by
the object that we see. For the point of introducing direct
perception was just so as to be able to contrast the two
sets of properties: we 'directly perceive', for instance, a
bent stick when we look through water at a stick that in
point of fact is straight.

Another and equally obvious argument, though the
other way round, i.e. in favour of saying that we do (di-
rectly) perceive the movement of the horsemen, is that
the horsemen are in movement. But this argument is
mutatis mutandis open to the same objection as the pre-
ceding one; for here we determine the properties that we
directly perceive by reference to the properties not of
what we are looking at but of what we are looking at a
representation of. And this seems, if anything, to com-
pound the error.

But does it compound the error? To think that it does seems to rest on an argument like this: When we say 'I see the representation of two horsemen in movement', this can be analysed into 'I see the representation of two horsemen in a certain position, *and* this position is one that can be assumed by horsemen in movement.' If we accept this analysis, it is obviously more plausible to appropriate, as the properties that we see, the properties of the static representation rather than the properties of the moving horsemen: for there is no reference to the moving horsemen in that part of the conjunct which is about what we see.

But why do we think that this conjunctive analysis of 'We see the representation of two horsemen in movement' is correct? And the answer presumably must be, because our seeing the representation of horsemen that we do and the represented horsemen's being in movement are independent facts: in other words, the representation that we see could be of, for instance, two horsemen carefully posed as if in movement. The representation is, as it were, neutral as to what if anything the horsemen are doing.

This might simply mean that Delacroix could have painted his picture from a scale model of two horsemen, which would, of course, have been static, rather than from two moving horsemen. But if he had, this would not have sufficed to make his picture a representation of a posed group. For we might have been quite unable to see the picture in this way: just as, for instance, we do not see Gainsborough's late landscapes as representations of the broken stones, pieces of looking glass and dried herbs from which he painted them – and for that matter just as Delacroix himself could not have seen the scale model from which (on the present supposition) he

painted, as itself of two horsemen in posed attitudes.

This is not to say that no representations of things or people in movement are neutral between their being or their not being in movement: many' cases of this kind could be cited from the hieratic forms of art. It is, though, to say that not all such representations are of this kind. To cite an extreme example: What sort of object could there be such that we could imagine Velasquez's stroboscopic representation of the spinning wheel in *Las Hilanderas* as a representation of it in repose?

I have argued that we do wrong to pick on either the representation itself or the thing represented as providing us with the sure criterion of what properties we directly perceive. But this has not led us to postulate as that criterion some mental image or picture, which is then called the direct object of perception: as traditional theory generally does. If there is such a thing as a criterion of what we directly perceive, it rather looks as though it is to be found in what we would naturally say in response to an outer picture. But if this is so, then there seems little hope that we can, without circularity, define or identify the properties of a picture by reference to what we directly perceive.

27

Before turning to the second of the two large sets of properties that I talked of in section 24 as constituting a serious challenge to the distinction upon which the Presentational theory rests, i.e. expressive properties, I should like to digress and in this section consider a rather special set of properties which are also problematic for the theory. For it would be hard to deny that these properties pertain to works of visual art: even if quite exaggerated claims have sometimes been made on their behalf. At the

same time it would not be easy to fit these properties into the dichotomy of given or inferred, which the theory demands: though, again, the attempt has certainly been made. Their connexion with representation makes it appropriate to discuss them here. The properties I refer to are best introduced by means of that highly versatile phrase, 'tactile values'.

The central or hard core use of this phrase (to get it over first) occurs inside a very general theory about visual art. This theory, which is widely associated with the name of Berenson, though it has a longer history, takes as its starting point a philosophical thesis. The thesis is the Berkleian theory of vision. According to this theory, which attributes to each of the human senses or perceptual modalities its own accusatives, sight takes for its 'proper objects' coloured or textured patches distributed in two dimensions: up-and-down, and across. From this it follows that we cannot directly see 'outness' or three-dimensionality. Three-dimensionality is something that we learn of through touch, which has for its proper objects things distributed in space. And if we ordinarily think that we can see things at a distance, not just in the sense that we can see things that are at a distance, but also in that we can see that things are at a distance, this is to be attributed to the constant correlations that hold between certain visual sensations and certain tactile sensations. In virtue of these correlations we are able straightaway to infer from the visual sensations that we receive to the associated tactile sensations that we are about to receive, or that we would receive if (say) we moved or stretched out a hand.

And if we now ask, How is it that in the visual or 'architectonic' arts we have an awareness of three-dimensionality, although paintings and sculptures are (irrel-

evancies apart) addressed, not just in the first instance but exclusively, to the sense of sight?, the answer is once again by appeal to association. This time, indeed, the appeal is twice over. In so far as representation of space or the third dimension is secured, this is because the painting or sculpture produces in us certain visual sensations, which, by putting us in mind of those other visual sensations which we would receive in presence from the objects represented, further put us in mind of the correlated tactile sensations. The power that a visual work of art possesses to produce in us visual sensations having this double set of associations to them is called its 'tactile values': and it is to tactile values exclusively that the capacity of the visual arts to represent space is ascribed. (We can now see what the irrelevancies I mentioned above are. They include any reference to the fact that paintings and sculpture are also tangible objects: for this fact is quite irrelevant, according to the theory, to the fact that they can represent tangible objects.)

It is not, however, with this strong use to which the notion of tactile values can be put that I am primarily concerned: though the use with which I am concerned is most successfully introduced via it. I will have already said enough to indicate why I find anything like the preceding theory untenable. I am concerned with the weaker or more local sense of the notion attached to it primarily by Wölfflin: in which only certain works of visual art are correctly spoken of, or their efficacy as representations analysed, in terms of tactile values. In *Classic Art*, and again in the *Principles of Art History*, Wölfflin attempted a very general division of visual works of art into two kinds or styles. The division he effected according to the way in which space is represen-

ted. No particular philosophical theory is presupposed concerning our awareness of space: and, indeed, it now turns out to be a characteristic only of works of art in one of the two great styles that space is represented by suggesting how things would seem to the sense of touch. This is a feature uniquely associated with the linear style: whereas inside the painterly style this is rejected and spatial representation is secured solely by appeal to the eye and visual sensation.

We might want to go beyond Wölfflin, well beyond him, in the distinctions we would make in the ways in which the third dimension can be represented. Nevertheless, there certainly seems to be a place somewhere or other for the phenomenon that in the extreme account is, for theoretical reasons, made universal: namely, the invocation of tactile sensations. We might say, standing in front of a Giotto or a Signorelli or a Braque *Atelier* (though not in front of, say, the mosaics in S. Apollinare Nuovo, or a Tintoretto, or a Gainsborough), that we can or could feel our way into the space. And the question arises, Is this kind of perception of space direct or indirect?

Reflection will show that it cannot be assigned, without detriment, to either of these two categories. To call it direct perception would be precisely to overlook the difference that has made us think of it as a *special* kind or type of perception in the first instance: the difference, that is, between the way of representing space to which it characteristically pertains, and the other way or ways of doing so which might be thought of as more straightforwardly visual in appeal. For if there is a way of representing space which makes no reference to sensations of touch, actual or recollected, then surely any way which involves the mediation of touch must give rise to a

kind of perception that falls on the indirect rather than the direct side.

However, if we think of the perception of space through tactile values as indirect, then this overlooks another difference. It overlooks what makes us think of this as a form of *perception* at all. Just as to think of such perception as immediate assimilates it to the kind of perception that we have in connexion with the more painterly modes of representation, so to call it indirect makes it impossible for us to distinguish it from cases where space is in no way represented but is indicated in some schematic or nonschematic fashion. The essential feature of the mode of representation we are considering is that it leads us by means of the manipulation of tactile cues to see space. The terminology of direct or indirect perception gives us no way of doing justice to both these aspects of the situation: that is, to the fact that the cues are *tactile*, and to the fact that on the basis of them we *see* something.

The difficulty is reflected in the peculiarly unhelpful phrase that is sometimes invoked, in this or analogous contexts, to characterize the sort of perception we have in looking at works of art that represent space in this way. We have, we are told, 'ideated sensations'. This phrase seems to be no more than a tribute to the attempt to condense into one two notions that have initially been determined as mutually incompatible, that is, direct and indirect perception. Everything points to the fact that what is wrong is the initial determination.

Wittgenstein, in the *Blue Book*, takes the case of the man, the water diviner, who tells us that, when he holds a certain rod, he feels that the water is five feet under the ground. If we are sceptical, we precipitate the response, 'Do you know all the feelings that there are? How do you

know that there isn't such a feeling?' Wittgenstein's account of what the diviner might say, equally of what should satisfy us, may not be altogether convincing, nor coherent with some of his later teaching; but it is obviously right in essentials. The man must explain the grammar of the phrase. And explaining the grammar of the phrase doesn't consist in simply breaking the phrase down into its constituents and explaining each in turn. Wittgenstein's example brings out this latter point very well: for we already know the meaning of 'feel' and 'water five feet under the ground'. We must understand how the phrase is used: how it latches on to other experiences and the ways in which we describe them. One thing that can prevent us from coming to understand this is any *a priori* theory as to what we can and what we cannot (directly) feel or perceive.

28

I am now ready to turn to expressive properties. In sections 15–19 I argued that there is no absurdity in attributing expressiveness as such to physical objects. The question I want to consider here is whether we can attribute specific expressive properties to physical objects solely on the basis of what is given. Of recent years a powerful and subtle argument has been brought forward to show that we cannot. This argument I shall call the Gombrich argument: though the actual argumentation I shall produce will be a reconstructed, and here and there a simplified, version of what is to be found in *Art and Illusion* and in the collection of essays entitled *Meditations on a Hobby Horse*.

The starting point of this argument is an attack on an alternative account of expression in terms of 'natural resonance'. According to this account, certain elements,

which can occur outside as well as inside art, e.g. colours, notes, have an intrinsic link with inner states, which they are thereby able both to express and to invoke: it is through the incorporation of these elements that works of art gain or have assigned to them this or that emotive significance. Such an account, Gombrich argues, is vulnerable because it overlooks the fact, to which a lot of art testifies, that one and the same element or complex of elements can have a quite different significance in different contexts. 'What strikes us as a dissonance in Haydn,' Gombrich writes, 'might pass unnoticed in a post-Wagnerian context and even the *fortissimo* of a string quartet may have fewer decibels than the *pianissimo* of a large symphony orchestra.' Again, Gombrich cites Mondrian's *Broadway Boogie-Woogie* which, he says, in the context of Mondrian's art is certainly expressive of 'gay abandon': but would have a quite different emotional impact on us if we learnt that it was by a painter with a propensity to involuted or animated forms, e.g. Severini.

What these examples show, Gombrich argues, is that a particular element has a significance for us only if it is regarded as a selection out of a specifiable set of alternatives. Blue as such has no significance: blue-rather-than-black has: and so has blue-rather-than-red though a different one. In the light of this, the notion of 'context' can be made more specific. In order for us to see a work as expressive, we must know the set of alternatives within which the artist is working, or what we might call his 'repertoire': for it is only by knowing from what point in the repertoire the work emerges that we can ascribe to it a particular significance. It is this fact that is totally ignored in the theory of natural resonance.

The scope of this argument might be misconstrued. For

it might be taken simply as an observation about how a spectator can acquire a certain skill, i.e. that of expressively understanding a painting; so that if he doesn't acquire this skill, the artist goes misunderstood. But this is to take too narrow a view of Gombrich's thesis: for what in effect he is doing is to lay down the conditions for expression itself. An artist expresses himself if, and only if, his placing one element rather than another on the canvas is a selection out of a set of alternatives: and this is possible only if he has a repertoire within which he operates. Knowledge of the repertoire is a presupposition of the spectator's capacity to understand what the artist is expressing: but the existence of the repertoire is a presupposition of the artist's capacity to express himself at all.

We may now ask: Granted that the spectator cannot understand the expressive significance of a work of art until he has knowledge of the artist's repertoire, why is it that, as soon as he does have knowledge of the artist's repertoire, he is able to come to an expressive understanding? To go back to the simplest example: If we need further knowledge before we can understand a particular placing of blue on the canvas, e.g. knowledge that it is a case of blue-rather-than-black, alternatively of blue-rather-than-red, why do we not need further knowledge before we can understand blue-rather-than-black, alternatively blue-rather-than-red? And the answer is that, though it is a matter of decision or convention what is the specific range of elements that the artist appropriates as his repertoire and out of which on any given occasion he makes his selection, underlying this there is a basis in nature to the communication of emotion. For the elements that the artist appropriates are a subset of an ordered series of elements, such that to one end of the series

we can assign one expressive value and to the other a contrary or 'opposite' value: and the crucial point is that both the ordering relation that determines the series, e.g. 'darker than' in the case of colours, 'higher than' in the case of musical notes (to give naïve examples), and the correlation of the two ends of the series with specific inner states, are natural rather than conventional matters. It is because a move towards one end of the series rather than the other is, or is likely to be, unambiguous that, once we know what alternatives were open to the artist, we can immediately understand the significance of his choice between them.

29

There is the question, which belongs presumably to psychology or so-called experimental aesthetics, whether in point of fact it is correct to regard the elements that comprise the constituents of art as falling into ordered series in respect of their expressive value. The question, however, which belongs to the philosophy of art is why someone with a theory of expression should have a special interest in maintaining that this is so.

If it is correct, as I have argued in section 18, that our disposition to consider inanimate objects as expressive has its roots in certain natural tendencies, i.e. that of producing objects to alleviate, and that of finding objects to match, our inner states, it is nevertheless evident that by the time we come to our attitude towards the objects of art, we have moved far beyond the level of mere spontaneity. To put it at its lowest: what is in origin natural is now reinforced by convention. Evidence for this exists in the fact that if someone is versed or experienced in art, no upper limit can be set to his capacity to understand expressively fresh works of art, even if both the works

themselves and what they express fall outside his experience. For what we might have expected is that his capacity to understand works of art would stop short at those correlations of objects and inner states with which he has a direct acquaintance. In point of fact the situation that obtains is close to that in language where, as it has been put (Chomsky), it is a central fact, to which any satisfactory linguistic theory must be adequate, that 'a mature speaker can produce a new sentence of his language on the appropriate occasion, and other speakers can understand it immediately, though it is equally new to them.' The implication would seem to be that there is, at least, a semantic aspect or component to the expressive function of art.

Nevertheless, there seems to be a difference. For even if a 'mature spectator of art' is in principle capable of an expressive understanding of any new work of art, just as the mature speaker can understand any new sentence in his language, still the understanding in the two cases would differ. For we see or experience the emotion in the work of art, we do not 'read it off'. In other words, if we press the parallel of expressive with semantic properties, we shall find ourselves thinking that art stands to what it expresses rather in the way that a black-and-white diagram with the names of the colours written in stands to a coloured picture: whereas the relation is more like that of a coloured reproduction to a coloured picture.

A technical way of making this point is to say that the symbols of art are always (to use a phrase that originates with Peirce) 'iconic'.

That works of art have this kind of translucence is a plausible tenet, and it should be apparent how a belief in a natural expressive ordering of the constituents of art

would go some way to preserving it. It would not, that is, preserve it in the strong sense, i.e. that from a simple observation of the work of art we could invariably know what it expressed: but it would preserve it in a weak sense, i.e. that once we knew what the work of art expressed, we could see that it did so. Since Gombrich has already maintained that some collateral information is essential for expressive understanding, he obviously does not require works of art to be iconic in the strong sense. Moreover, there is a general argument against maintaining that they are: namely, that the element of inventiveness that we believe to be intrinsic to art would be in jeopardy. A work of art would threaten to be little more than an assemblage or compilation of pre-existent items.

30

Let us now return to the Gombrich argument itself. The argument is obviously very powerful; nevertheless, there are certain significant difficulties to it, which largely concern the idea of the repertoire and how the repertoire is determined for any given artist.

As a starting point it might be suggested that we should identify the repertoire with the range of the artist's actual works. But this is unacceptable: because, except in one limiting case, it gives us the wrong answer, and, even when it gives us the right answer, it does so for the wrong reason.

The limiting case is where the artist in the course of his work expresses the full range of inner states conceivable for him: where, to put it another way, there is nothing that he could have expressed that he didn't. In all other cases there will be parts of the repertoire that were not employed, i.e. the parts that he would have employed if

he had expressed those states which he didn't, and the question then arises how we are to reconstruct these parts. And the answer must ultimately come to this: that we ask ourselves how the artist would have expressed those states which he never expressed. In other words, we credit him with certain hypothetical works. But on the Gombrich argument this becomes impossible. For it is obvious that, before we can even set about doing this, we must first know what states the artist did express, i.e. in his actual works, but this, Gombrich argues, we cannot do until we know the repertoire as a whole. So we can never start.

To put the matter another way: Confronted with the *œuvre* of a given artist, how are we to decide, on the Gombrich argument, whether this is the work of an artist who within a narrow repertoire expressed a wide range of inner states, or of one who within a much broader repertoire expressed a narrow range of states? Internal evidence is indifferent as to the two hypotheses: and it is unclear what external evidence the argument allows us to invoke.

I have said that, even in the limiting case where the identification of repertoire with the range of actual works gives us the right answer, it does so for the wrong reason. What I had in mind is this: that it isn't the fact that such and such a range of works is everything that the artist in fact produced that makes this range his repertoire. For otherwise the identification of repertoire with actual range would be correct in all cases. It is rather that the range as we have it coincides with everything he could have produced. But how (and here the question comes up again) do we establish what he could, and what he could not, have produced?

One suggestion is that we should, at this stage, go back

to the artist's situation. In other words, we do wrong to try to determine the repertoire by reference to how the spectator would determine it. For what the spectator does is at best to reconstruct what the artist has initially done.

But do we have greater success in arriving at the repertoire by considering it from the artist's point of view? There is once again a limiting case. And this is where the artist *explicitly* sets up a range of alternatives within which he works: or where the constraints of nature or society prescribe precisely what he may do. Such cases will be very rare. Otherwise, we simply have the artist at work. And if it is now asserted that we can observe the artist implicitly choosing between alternatives, the question arises, How can we distinguish between the trivial case, where the artist does one thing, e.g. A, and not another, e.g. B (where this just follows from A and B being distinct), and the case that is of interest to us, where the artist does A in preference to B? One suggestion might be that we are entitled to say the latter where it is clear that, if the artist had done B, it would have expressed something different for him. But on the Gombrich argument this is something we can say only after we have determined the repertoire: hence we cannot use it in order to determine the repertoire.

31

The preceding objection may seem very abstract: which indeed it is. But this is only a reflection of the extremely abstract character of the argument itself, from which indeed it gains a great deal of its plausibility. For what it leaves out of account, or introduces only in an unrecognizable form, is the phenomenon of style and the corresponding problem of style formation.

For the notion of style cannot be unreservedly equated with that of the repertoire. For what we think of as a style has a kind of inner coherence that a mere repertoire lacks. This is well brought out in a supposition that, as we have seen, Gombrich asks us to consider in the course of expounding his argument. Let us suppose, he writes, that Mondrian's *Broadway Boogie-Woogie* had been painted by Severini. . . . But if this appeal is not to be taken in such a way that the names 'Mondrian' and 'Severini' function as mere dummies or variables, it is hard to know how to interpret it. For the only way in which the hypothetical situation would be conceivable, would be if we imagined that for a phase Severini adopted the style of Mondrian as a *pasticheur*. Now such an eventuality would occasion an increase in the range of Severini's repertoire but without any corresponding increase in the range of his style. The same phenomenon occurs less schematically in the case of an artist in whose work we notice a sharp break of style (e.g. Guercino). These cases show us that what we should really be interested in is style, not repertoire.

There are two further differences between a style and a repertoire, both of which are relevant to the issue of expressive understanding. The first is that a style may have been formed in order to express a limited range of emotions, and in such cases it is virtually impossible for us to imagine the expression of a state which falls outside this range being accomplished within the style. The supposition of an optimistic painting by Watteau, or a monumental sculpture by Luca della Robbia, or a tortured or tempestuous group by Clodion, all verge upon absurdity. Secondly – and this is a closely connected point – a style may have such an intimate connexion or correspondence with the states that are typically ex-

pressed within it, that we do not have to go outside the work itself and examine related cases in order to gauge its expressive significance. A style could be self-explanatory.

Wölfflin, in the introduction to the *Principles of Art History*, sets out to characterize what he calls 'the double root of style'. What in point of fact he does is to separate out two levels on which style can occur: perhaps even two senses of the word 'style'. On the one hand, there are the many particular styles, the styles of individuals or nations, which vary according to temperament or character and are primarily expressive. On the other hand, there is style in some more general sense, in which a style approximates to a language. In the first sense, Terborch and Bernini (the examples are Wölfflin's) have their own very differing styles, being very different kinds of artist; in the second sense, they share a style. Each style in the first sense corresponds to, or reflects, a preselection of what is to be expressed or communicated. By contrast a style in the second sense is a medium within which 'everything can be said'. (We may for our purpose disregard Wölfflin's insistence that a style in this latter sense, of which for him the supreme, perhaps the sole, instances are the linear and the painterly, exhibits a distinctive 'mode of vision' or incorporates specific 'categories of beholding': phrases which the *Principles* does little to illuminate.) Now, the point I have been making about the Gombrich argument might be put by saying that it recognizes style only in the second of Wölfflin's senses, in which it is something akin to language. Where Gombrich, of course, differs from Wölfflin is in the variety of such styles that he thinks to exist: there being for him roughly as many styles in this sense as there are for Wölfflin styles in his first sense.

Another way of making the same point would be to say that for Gombrich a style is roughly equivalent to a method of projection in cartography. We can make a map of any region of the world according to any projection: although some methods of projection may be more suitable for one region than another. The difference simply is that the region, alternatively the map, will look quite different, depending on which projection is actually employed.

We now need to consider as a whole the argument of the last three sections. Its effect has undoubtedly been to disturb some of the detail of Gombrich's account of expressive understanding. Nevertheless, the considerations that he raises leave little doubt about the important part that collateral information does play in our aesthetic transactions. Accordingly, they show the implausibility of the very restricted view of a work of art that is central to the Presentational theory.

32

The reference to the notion of 'style' could serve to introduce the second set of arguments against the Presentational theory. For 'style' would seem to be a concept that cannot be applied to a work of art solely on the basis of what is presented and yet is also essential to a proper understanding or appreciation of the work. And the same can be said of the various particular stylistic concepts, e.g. 'gothic', 'mannerist', 'neo-romantic'.

However, in this section I want to consider not these concepts but another group whose claim not to be based upon presentation is even clearer, but whose centrality to art has been, and still is, disputed in a most interesting controversy. From Aristotle onwards it has been a tenet of the traditional rhetoric that the proper understanding

of a literary work involves the location of it in the correct genre: the recognition of it, that is, as drama, epic, or lyric. It has been no less characteristic of 'modern' criticism that it completely rejects such categorization of art. The concession is made that the various labels might have a utility in, say, librarianship or literary history: but they have nothing to tell us about the aesthetic aspect of a work of art. They are (to use a phrase that has varied implications) *a posteriori*.

A typical argument to this effect occurs in Croce. Croce links the thesis that works of art can be classified into genres with the (to him) no less objectionable thesis that works of art can be translated. For the two theses share the presupposition that works of art divide into form and content: the content being that which, in translation, gets carried over into the foreign language or, in the traditional rhetoric, is realized inside the relevant genre. But this presupposition is wrong because works of art have an inherent unity or uniqueness. Croce concedes that there could be a purely practical or nonaesthetic role for the traditional taxonomy. Employed however as an instrument of analysis or criticism, it utterly distorts the nature of art.

Croce's argument is certainly open to criticism internally. For it seems to be based on the assumption that, if we classify a work as in one genre, we are implicitly saying that it might or could have been in another genre: hence we implicitly divide it into form (which is alterable) and content (which is constant). But the only reason for thinking that there is this implication to what we say is some general philosophical thesis to the effect that if we say a is f, we must be able to imagine what it would be like for a not to be f but to be, say, g, where g is a contrary of f. But this thesis, which has some plausibility,

is false over a range (and an interesting range) of cases, i.e. where we cannot identify *a* except by reference (explicit or implicit) to *f*. And it might well be that we could not identify *Paradise Lost* except as an epic or *Hamlet* except as a drama. Indeed Croce's own parallel with the translatability thesis should have alerted him to the weakness of his argument. For Carducci's *Alla Stazione* may be untranslatable; none the less it is in Italian, which, if Croce's argument is contraposed, should be false. Accordingly, what there is of weight in Croce's critique of genres, and what indeed has weighed heavily with many modern theorists, lies not in the formal argument, but rather in his insistence, unspecific and ambiguous though this sometimes seems, on what is referred to as the uniqueness of any work of art.

(Another argument against genre-criticism, of which a certain amount has been heard in recent theory, is that it distorts not so much our proper understanding of a work of art as our proper evaluation of it. But the assumption that underlies this variant is no less erroneous than that which underlies Croce's. For the assumption is that, if we classify something as an opera, this determines the criteria by which we must evaluate it: for our evaluation of it will consist in showing the extent to which it satisfies the criteria of being an opera: in other words, to say that something is a good opera is to say that it is to a very high degree an opera. The assumption has only to be spelt out for its absurdity to be realized.)

Recently an argument of extreme ingenuity has been brought forward by Northrop Frye to controvert this whole contention. Central to this argument is the notion of the 'radical of presentation': which means, roughly, how the words in a given text are to be taken. Starting the problem at its lowest, we might imagine ourselves

confronted with two pages in which the lines are printed so that they do not run to the end. One (*Paradise Lost*) is to be read as an epic: the other (*Bérénice*) is to be read as a play: The difference lies, we can now say, in the radical of presentation.

It is important to realize that the differences of which this argument takes account are those which should be construed as essential differences. For instance, we could imagine in an English class *Paradise Lost* being read 'round the form': on a higher level we could imagine an epic being presented on the stage in such a way that different actors read or sang the cited words of the characters and a narrator narrated the text, as in Monteverdi's *Combattimento di Tancredi e Clorinda*. But these readings would be accidental, if not actually inimical, to the nature of the work. On the other hand, that the text of *Hamlet* should be presented on a stage, that different actors should recite different sections of it, that the recitation should be more or less consecutive from beginning to end, that certain effects should accompany the recitation so as to enhance verisimilitude – these are not accidental: a reading of the text that was done in ignorance of, or indifference to, them would be not so much incomplete as mistaken.

Nevertheless – and here we come to the crux of the argument – there is nothing in the text that indicates such a distinction unambiguously: nor could there be. There are, of course, certain accepted typographical conventions that distinguish printed plays from printed poems. But, as readers of literature, we have to know how to interpret these conventions: we must not be like the child who, in learning his part, learns the stage directions as well. And such an interpretation is always in terms of certain aesthetic conventions which the reading

presupposes. 'The genre', Frye puts it, 'is determined by the conditions established between the poet and his public.'

Once we have admitted these distinctions, Frye argues, we cannot stop here. For continuous with the distinction between poetry where the poet is concealed from his audience (drama) and poetry where he is not, there is a further distinction within the latter category between the case where the poet addresses his audience (epic) and the case where he is overheard (lyric). Whether in fact this is a legitimate continuation of the argument, and how far, if it is, it re-establishes the traditional categories are matters that I do not need to pursue. I have not stated the argument against, therefore I shall not consider the argument for, genre-criticism in so far as this relates to the adequacy of the traditional classification. It would be enough if it could be established that some such classification is intrinsic to literary understanding: and certainly the 'radical of presentation' strongly suggests that it is.

33

It might now be suggested that considerations like the foregoing can be reconciled within the Presentational theory by treating the critical or rhetorical concepts that are essential to our understanding of art as part of the conceptual framework, or (in psychological terminology) the mental set, with which we are required to approach art. Some philosophers of art who have argued for a theory very like the Presentational theory (Kant, Fiedler) have, it is true, stipulated that we should free ourselves from all concepts when we approach art: but it is hard to attach much sense to such an extreme demand.

A difficulty with the present suggestion is to see precisely its scope: what does it, and what can it not, accommodate to the theory? Can it, for instance, take care of the many cases of what might generally be called 'expectancy' which seem inherent to our aesthetic understanding: cases, that is, where certain anticipations are aroused by one part of a work of, say, music or architecture, to be satisfied, alternatively to be frustrated, by another? An example, for instance, would be the practice, cited by Wölfflin in *Renaissance and Baroque* as typical of early Baroque (Mannerist) palace architecture, of contrasting a façade or a vestibule with the interior courtyard: as, for instance, in the Palazzo Farnese. Or again – and this example is more contentious, since the time order is reversed – it has been argued that we hear the flute solo at the beginning of *L'Après-Midi d'un Faune* differently from what we would were it the opening music of a sonata for unaccompanied flute: the presence of the orchestra makes itself felt.

Roughly the point at which the Presentational theory would seem to prove recalcitrant is where that which we 'import' into our perception of a work of art cannot be treated as a concept that we apply to the work on the basis of its characteristics, but is ineliminably propositional: where, that is, it consists in a piece of information that cannot be derived from (though, of course, it may be confirmed by) the manifest properties of the work. In an essay entitled 'The History of Art as a Humanistic Discipline', Erwin Panofsky has presented a powerful argument to show that there are cases where our understanding of a work of (visual) art and its stylistic peculiarities depends upon reconstructing the artistic 'intentions' that went to its making, and to do this depends in turn upon identifying the 'artistic problems'

to which it is a solution. The identification of an artistic problem seems definitely propositional.

On the face of it, Panofsky's contention seems irrefutable, at any rate over a certain range of art. Take, for instance, the much-imitated Gibbs façade of St Martin-in-the-Fields. In order to understand not merely its profound influence, but also it in itself, we need to see it as a solution to a problem which had for fifty years exercised English architects: how to combine a temple façade or portico with the traditional English demand for a west tower. If we omit this context, much in the design is bound to seem wilful or bizarre.

To settle this, or the many analogous issues, that arise on Panofsky's contention would require detailed incursions into art-historical material. Here it may suffice to point out a tactic characteristically adopted by those who ostensibly reject the contention. In each case what they argue is that either the work of art is defective since it needs to be elucidated externally, or else the problem to which it is a solution or the intention which inspired it is something which is fully manifest in the work taken as a presentational object. We find this argument in e.g. Wind, and Monroe Beardsley. But of the counter-argument so framed it is pertinent to ask, Manifest to whom? And the answer must be, To someone reasonably well versed in art. In other words, the original argument is not really rejected. The counterargument merely restricts the kind of information that may be 'imported': the information must not exceed that which an amateur of the arts would naturally bring with him. If such a person cannot reconstruct the problem to which the given work of art is a solution, then, but only then, knowledge that the problem is of such and such a nature is irrelevant. Furthermore, the capacity to see, given the

problem and the work of art, that the latter is a solution to the former already presupposes familiarity with art. It may be self-evident that $2 + 2 = 4$: but not to someone ignorant of what addition is.

Moreover, it is worth pointing out that there is an analogue inside the Panofsky contention to the restriction that his critics would place upon the kind of knowledge imported. For if it is necessary to import specious forms of knowledge, this would, on the Panofsky contention, count as an adverse factor in our appreciation of, or our judgement upon, the work of art. We might reconstruct the dialogue roughly as follows: Beardsley would say: Since this evidence is so esoteric, we can't take it into account in judging the work; whereas Panofsky would say: Since the evidence we have to take into account is so esoteric, we cannot judge the work favourably. The difference is not so great.

Sometimes the attempt is made to reconcile the adversaries in this argument by pointing out that they are employing different senses of 'problem' or 'intention': the artist's problem versus the problem of the work, or the artist's ulterior intention versus his immediate intention. But I doubt if such an analysis will get to the core of the difficulty: since, only the shortest distance below the surface, these different 'senses' of the same word are interrelated.

34

It would certainly seem as though there is one element that we must bring to our perception of a work of art, which is quite incompatible with the Presentational theory: and that is the recognition that it is a work of art. At first it might be thought that this could be accommodated to the theory, along the lines I indicated at the

beginning of the last section. We might, that is, regard the concept 'art' as part of the conceptual framework with which we are required to approach art. But this will not do, except on the most literal level. 'Art' certainly is a concept, but (as this essay implicitly shows) it is a concept of such complexity that it is hard to see how it could be fitted into an argument designed with merely descriptive or rhetorical concepts in mind.

35

Before, however, pursuing this last point, the consequences of which will occupy us more or less for the rest of this essay, I want to break off the present discussion (which began with section 20) and go back and take up an undischarged commitment: which is that of considering the consequences of rejecting the hypothesis that works of art are physical objects, in so far as those arts are concerned where there is no physical object with which the work of art could be plausibly identified. This will, of course, be in pursuance of my general aim – which has also directed the preceding discussion – of establishing that the rejection of the hypothesis has serious consequences for the philosophy of art only in so far as those arts are concerned where there *is* such an object.

I have already stated (sections 5, 20) that, once it is conceded that certain works of art are not physical *objects*, the subsequent problem that arises, which can be put by asking, What sort of thing are they?, is essentially a logical problem. It is that of determining the criteria of identity and individuation appropriate to, say, a piece of music or a novel. I shall characterize the status of such things by saying that they are (to employ a term introduced by Peirce) *types*. Correlative to the term 'type' is the term 'token'. Those physical objects which (as we

have seen) can out of desperation be thought to be works of art in cases where there are no physical objects that can plausibly be thought of in this way, are *tokens*. In other words, *Ulysses* and *Der Rosenkavalier* are types, my copy of *Ulysses* and tonight's performance of *Rosenkavalier* are tokens of those types. The question now arises, What is a type?

The question is very difficult, and unfortunately, to treat it with the care and attention to detail that it deserves is beyond the scope of this essay.

We might begin by contrasting a type with other sorts of thing that it is not. Most obviously we could contrast a type with a *particular*: this I shall take as done. Then we could contrast it with other various kinds of non-particulars: with a *class* (of which we say that it has *members*), and a *universal* (of which we say that it has *instances*). An example of a class would be the class of red things: an example of a universal would be redness: and examples of a type would be the word 'red' and the Red Flag – where this latter phrase is taken to mean not this or that piece of material, kept in a chest or taken out and flown at a masthead, but the flag of revolution, raised for the first time in 1830 and that which many would willingly follow to their death.

Let us introduce as a blanket expression for types, classes, universals, the term *generic entity*, and, as a blanket expression for those things which fall under them, the term *element*. Now we can say that the various generic entities can be distinguished according to the different ways or relationships in which they stand to their elements. These relationships can be arranged on a scale of intimacy or intrinsicality. At one end of the scale we find classes, where the relationship is at its most external or extrinsic: for a class is merely made of, or constituted

by, its members which are extensionally conjoined to form it. The class of red things is simply a construct out of all those things which are (timelessly) red. In the case of universals the relation is more intimate: in that a universal is present in all its instances. Redness is in all red things. With types we find the relationship between the generic entity and its elements at its most intimate: for not merely is the type present in all its tokens like the universal in all its instances, but for much of the time we think and talk of the type as though it were itself a kind of token, though a peculiarly important or pre-eminent one. In many ways we treat the Red Flag as though it were a red flag (cf. 'We'll keep the Red Flag flying high').

These varying relations in which the different generic entities stand to their elements are also reflected (if, that is, this is *another* fact) in the degree to which both the generic entities and their elements can satisfy the same predicates. Here we need to make a distinction between sharing properties and properties being transmitted. I shall say that when A and B are both *f*, *f* is shared by A and B. I shall further say that when A is *f* because B is *f*, or B is *f* because A is *f*, *f* is transmitted between A and B. (I shall ignore the sense or direction of the transmission, i.e. I shall not trouble, even where it is possible, to discriminate between the two sorts of situation I have mentioned as instances of transmission.)

First, we must obviously exclude from consideration properties that can pertain only to tokens (e.g. properties of location in space and time) and equally those which pertain only to types (e.g. 'was invented by'). When we have done this, the situation looks roughly as follows: Classes can share properties with their members (e.g. the class of big things is big), but this is very rare: moreover,

where it occurs it will be a purely contingent or for-
tuitous affair, i.e. there will be no transmitted properties.
In the cases of both universals and types, there will be
shared properties. Red things may be said to be exhilar-
ating, and so also redness. Every red flag is rectangular,
and so is the Red Flag itself. Moreover, many, if not all, of
the shared properties will be transmitted.

Let us now confine our attention to transmitted proper-
ties because it is only they which are relevant to the
difference in relationship between, on the one hand, uni-
versals and types and, on the other hand, their elements.
Now there would seem to be two differences in respect of
transmitted properties which distinguish universals from
types. In the first place, there is likely to be a far larger
range of transmitted properties in the case of types than
there is with universals. The second difference is this: that
in the case of universals no property that an instance of a
certain universal has necessarily, i.e. that it has in virtue
of being an instance of that universal, can be transmitted
to the universal. In the case of types, on the other hand,
all and only those properties that a token of a certain
type has necessarily, i.e. that it has in virtue of being a
token of that type, will be transmitted to the type.
Examples would be: Redness, as we have seen, may be
exhilarating, and, if it is, it is so for the same reason that
its instances are, i.e. the property is transmitted. But
redness cannot be red or coloured, which its instances are
necessarily. On the other hand, the Union Jack is
coloured and rectangular, properties which all its tokens
have necessarily: but even if all its tokens happened to be
made of linen, this would not mean that the Union Jack
itself was made of linen.

To this somewhat negative account of a type – con-
centrated largely on what a type is not – we now need to

append something of a more positive kind, which would say what it is for various particulars to be gathered together as tokens of the same type. For it will be appreciated that there corresponds to every universal and to every type a class: to redness the class of red things, to the Red Flag the class of red flags. But the converse is not true. The question therefore arises, What are the characteristic circumstances in which we postulate a type? The question, we must appreciate, is entirely conceptual: it is a question about the structure of our language.

A very important set of circumstances in which we postulate types – perhaps a central set, in the sense that it may be possible to explain the remaining circumstances by reference to them – is where we can correlate a class of particulars with a piece of human invention: these particulars may then be regarded as tokens of a certain type. This characterization is vague, and deliberately so: for it is intended to comprehend a considerable spectrum of cases. At one end we have the case where a particular is produced, and is then copied: at the other end, we have the case where a set of instructions is drawn up which, if followed, give rise to an indefinite number of particulars. An example of the former would be the Brigitte Bardot looks: an example of the latter would be the Minuet. Intervening cases are constituted by the production of a particular which was made in order to be copied, e.g. the Boeing 707, or the construction of a mould or matrix which generates further particulars, e.g. the Penny Black. There are many ways of arranging the cases – according, say, to the degree of human intention that enters into the proliferation of the type, or according to the degree of match that exists between the original piece of invention and the tokens that flow from it. But there are certain resemblances between all the cases: and with ingenuity

one can see a natural extension of the original characterization to cover cases where the invention is more classificatory than constructive in nature, e.g. the Red Admiral.

36

It will be clear that the preceding characterization of a type and its tokens offers us a framework within which we can (at any rate roughly) understand the logical status of things like operas, ballets, poems, etchings, etc.: that is to say, account for their principles of identity and individuation. To show exactly where these various kinds of things lie within this framework would involve a great deal of detailed analysis, more than can be attempted here, and probably of little intrinsic interest. I shall touch very briefly upon two general sets of problems, both of which concern the feasibility of the project. In this section I shall deal with the question of how the type is identified or (what is much the same thing) how the tokens of a given type are generated. In the next section I shall deal with the question of what properties we are entitled to ascribe to a type. These two sets of questions are not entirely distinct: as we can see from the fact that there is a third set of questions intermediate between the other two, concerning how we determine whether two particulars are or are not tokens of the same type. These latter questions, which arise for instance sharply in connexion with translation, I shall pass over. I mention them solely to place those which I shall deal with in perspective.

First, then, as to how the type is identified. In the case of any work of art that it is plausible to think of as a type, there is what I have called a piece of human invention: and these pieces of invention fall along the whole

spectrum of cases as I characterized it. At one end of the scale, there is the case of a poem, which comes into being when certain words are set down on paper or perhaps, earlier still, when they are said over in the poet's head (cf. the Croce–Collingwood theory). At the other end of the scale is an opera which comes into being when a certain set of instructions, i.e. the score, is written down, in accordance with which performances can be produced. As an intervening case we might note a film, of which different copies are made: or an etching or engraving, where different sheets are pulled from the same matrix, i.e. the plate.

There is little difficulty in all this, so long as we bear in mind from the beginning the variety of ways in which the different types can be identified, or (to put it another way) in which the tokens can be generated from the initial piece of invention. It is if we begin with too limited a range of examples that distortions can occur. For instance, it might be argued that, if the tokens of a certain poem are the many different inscriptions that occur in books reproducing the word order of the poet's manuscript, then 'strictly speaking' the tokens of an opera must be the various pieces of sheet music or printed scores that reproduce the marks on the composer's holograph. Alternatively, if we insist that it is the performances of the opera that are the tokens, then, it is argued, it must be the many readings or 'voicings' of the poem that are *its* tokens.

Such arguments might seem to be unduly barren or pedantic, if it were not that they revealed something about the divergent media of art: moreover, if they did not bear upon the issues to be discussed in the next section.

37

It is, we have seen, a feature of types and their tokens, not merely that they may share properties, but that when they do, these properties may be transmitted. The question we have now to ask is whether a limit can be set upon the properties that may be transmitted: more specifically, since it is the type that is the work of art and therefore that with which we are expressly concerned, whether there are any properties – always of course excluding those properties which can be predicated only of particulars – that belong to tokens and cannot be said *ipso facto* to belong to their types.

It might be thought that we have an answer, or at least a partial answer, to this question in the suggestion already made, that the properties transmitted between token and type are only those which the tokens possess necessarily. But a moment's reflection will show that any answer along these lines is bound to be trivial. For there is no way of determining the properties that a token of a given type has necessarily, independently of determining the properties of that type: accordingly, we cannot use the former in order to ascertain the latter. We cannot hope to discover what the properties of the Red Flag are by finding out what properties the various red flags have necessarily: for how can we come to know that, e.g. this red flag is necessarily red, prior to knowing that the Red Flag itself is red?

There are, however, three observations that can be made here on the basis of our most general intuitions. The first is that there are no properties or sets of properties that cannot pass from token to type. With the usual reservations, there is nothing that can be predicated of a performance of a piece of music that could not also be

predicated of that piece of music itself. This point is vital. For it is this that ensures what I have called the harmlessness of denying the physical-object hypothesis in the domain of those arts where the denial consists in saying that works of art are not physical *objects*. For though they may not be objects but types, this does not prevent them from having physical properties. There is nothing that prevents us from saying that Donne's *Satires* are harsh on the ear, or that Dürer's engraving of St Anthony has a very differentiated texture, or that the conclusion of 'Celeste Aida' is *pianissimo*.

The second observation is that, though any single property may be transmitted from token to type, it does not follow that all will be: or to put it another way, a token will have some of its properties necessarily, but it need not have all of them necessarily. The full significance of this point will emerge later.

Thirdly, in the case of *some* arts it is necessary that not all properties should be transmitted from token to type: though it remains true that for any single property it might be transmitted. The reference here is, of course, to the performing arts – to operas, plays, symphonies, ballet. It follows from what was said above that anything that can be predicated of a performance of a piece of music can also be predicated of the piece of music itself: to this we must now add that not every property that can be predicated of the former *ipso facto* belongs to the latter. This point is generally covered by saying that in such cases there is essentially an element of *interpretation*, where for these purposes interpretation may be regarded as the production of a token that has properties in excess of those of the type.

'Essentially' is a word that needs to be taken very seriously here. For, in the first place, there are certain

factors that might disguise from us the fact that every performance of a work of art involves, or is, an interpretation. One such factor would be antiquarianism. We could – certainly if the evidence were available – imagine a *Richard III* produced just as Burbage played it, or *Das Klagende Lied* performed just as Mahler conducted it. But though it would be possible to bring about in this way a replica of Burbage's playing or Mahler's conducting, we should none the less have interpretations of *Richard III* and *Das Klagende Lied*, for this is what Burbage's playing and Mahler's conducting were, though admittedly the first. Secondly, it would be wrong to think of the element of interpretation – assuming that this is now conceded to be present in the case of all performances – as showing something defective. Susanne Langer, for instance, has characterized the situation in the performing arts by saying that e.g. the piece of music the composer writes is 'an incomplete work': 'the performance', she says, 'is the completion of a musical work'. But this suggests that the point to which the composer carries the work is one which he could, or even should, have gone beyond. To see how radical a reconstruction this involves of the ways in which we conceive the performing arts, we need to envisage what would be involved if it were to be even possible to eliminate interpretation. For instance, one requirement would be that we should have for each performing art what might be called, in some very strong sense, a universal notation: such that we could designate in it every characteristic that now originates at the point of performance. Can we imagine across the full range of the arts what such a notation would be like? With such a notation there would no longer be any executant arts: the whole of the execution would have been anticipated in the notation. What assurance can we have that

the reduction of these arts to mere mechanical skills would not in turn have crucial repercussions upon the way in which we regard or assess the performing arts?

38

However, if we no longer regard it as a defect in certain arts that they require interpretation, it might still seem unsatisfactory that there should be this discrepancy within the arts: that, for instance, the composer or the dramatist should be denied the kind of control over his work that the poet or the painter enjoys.

In part, there just *is* a discrepancy within the arts. And this discrepancy is grounded in very simple facts of very high generality, which anyhow lie outside art: such as that words are different from pigments, or that it is human beings we employ to act and human beings are not all exactly alike. If this is the source of dissatisfaction, the only remedy would be to limit art very strictly to a set of processes or stuffs that were absolutely homogeneous in kind.

In part, however, the dissatisfaction comes from exaggerating the discrepancy, and from overlooking the fact that in the nonperforming arts there is a range of ways in which the spectator or audience can take the work of art. It is, I suggest, no coincidence that *this* activity, of taking the poem or painting or novel in one way rather than another, is also called 'interpretation'. For the effect in the two cases is the same, in that the control of the artist over his work is relaxed.

Against this parallelism between the two kinds of interpretation, two objections can be raised. The first is that the two kinds of interpretation differ in order or level. For whereas performative interpretation occurs only

with certain arts, critical interpretation pertains to all: more specifically a critical interpretation can be placed upon any given performative interpretation – so the point of the parallelism vanishes, in that the performing arts still remain in a peculiar or discrepant situation. Now I do not want to deny that any performance of a piece of music or a play can give rise to a critical interpretation; the question, however, is, When this happens, is this on the same level as a performative interpretation? I want to maintain that we can fruitfully regard it as being so. For in so far as we remain concerned with the play or the piece of music, what we are doing is in the nature of suggesting or arguing for alternative performances, which would have presented the original work differently: we are not suggesting or arguing for alternative ways in which the actual performance might be taken. Our interpretation is on the occasion of a performance, not about it. The situation is, of course, complicated to a degree that cannot be unravelled here by the fact that acting and playing music are also arts, and in criticizing individual performances we are sometimes conversant about those arts: which is why I qualified my remark by saying 'in so far as we remain concerned with the play or piece of music'.

The second and more serious objection to the parallelism between the two kinds of interpretation is that they differ as to necessity. For whereas a tragedy or a string quartet have to be interpreted, a poem or a painting need not be. At any given moment it may be necessary to interpret them, but that will be only because of the historical incompleteness of our comprehension of the work. Once we have really grasped it, further interpretation will no longer be called for. In other words, critical interpretation ultimately eliminates itself: whereas a

piece of music or a play cannot be performed once and for all.

On this last argument I wish to make two preliminary observations: First, the argument must not draw any support (as the formulation here would seem to) from the indubitable but irrelevant fact that a performance is a transient not an enduring phenomenon. The relevant fact is not that a piece of music or a play must always be performed anew but that it can always be performed afresh, i.e. that every new performance can involve a new interpretation. The question then is, Is there not in the case of the nonperforming arts the same permanent possibility of new interpretation? Secondly, the argument seems to be ambiguous between two formulations, which are not clearly, though in fact they may be, equivalent: the ostensibly stronger one, that in the case of a poem or painting all interpretations can ultimately be eliminated; and the ostensibly weaker one, that in these cases all interpretations save one can ultimately be eliminated.

Against the eliminability of interpretation, the only decisive argument is one drawn from our actual experience of art. There are, however, supplementary considerations, the full force of which can be assessed only as this essay progresses, which relate to the value of art. Allusions to both can be found in a brilliant and suggestive work, Valéry's 'Réflexions sur l'Art'.

In the first place the value of art, as has been traditionally recognized, does not exist exclusively, or even primarily, for the artist. It is shared equally between the artist and his audience. One view of how this sharing is effected, which is prevalent but implausible, is that the artist makes something of value, which he then hands on to the audience, which is thereby enriched. Another view

is that in art there is a characteristic ambiguity, or perhaps better plasticity, introduced into the roles of activity and passivity: the artist is active, but so also is the spectator, and the spectator's activity consists in interpretation. 'A creator', Valéry puts it, 'is one who makes others create.'

Secondly – and this point too has received some recognition – the value of art is not exhausted by what the artist, or even by what the artist and the spectator, gain from it: it is not contained by the transaction between them.

The work of art itself has a residual value. In certain 'subjectivist' views – as e.g. in the critical theory of I. A. Richards – the value of art is made to seem contingent: contingent, that is, upon there being found no better or more effective way in which certain experiences assessed to be valuable can be aroused in, or transmitted between, the minds of the artist and his audience. Now it is difficult to see how such a conclusion can be avoided if the work of art is held to be inherently exhaustible in interpretation. In section 29 the view was considered that works of art are translucent; the view we are now asked to consider would seem to suggest that they are transparent, and as such ultimately expendable or 'throw-away'. It is against such a view that Valéry argued that we should regard works of art as constituting 'a new and impenetrable element' which is interposed between the artist and the spectator. The ineliminability of interpretation he characterizes, provocatively, as 'the creative misunderstanding'.

39

The word 'interpretation' has very definite associations. For the interpretative situation is one we in general con-

ceive somewhat as follows: There are certain facts of the
case; these facts can be conclusively established by refer-
ence to evidence; there are also certain constructions that
can be placed upon these facts, these constructions,
which are what we call 'interpretations', are not
uniquely determined by the facts, nor is there any other
way in which they can be conclusively established; in-
terpretations are, therefore, assessed by reference to prag-
matic considerations, or to considerations of theory,
intuition, judgement, taste, plausibility etc.; the dis-
tinction between fact and interpretation is com-
paratively clear-cut.

In the domain of the arts this picture has to be
considerably revised: notably, in two respects, both of
which are very important for the proper understanding
of art.

In the first place, in the case of a work of art what the
facts are is not something that can legitimately be demar-
cated. The point here is not just that disputes can always
arise on the margin as to whether something is or is not a
fact about a given work of art. The position is more rad-
ical. It is that whole ranges of fact, previously unnoticed
or dismissed as irrelevant, can suddenly be seen to pertain
to the work of art. These transformations can occur in a
variety of ways as a result of changes in criticism, or as
the result of changes in the practice of art, or as a result
of changes in the general intellectual environment: as the
following examples show.

As a first example, we might cite the grammaticality of
Shakespeare's sentences, which has over history been re-
garded as a matter primarily of philological interest.
Recently, however, critics have suggested that the
syntactical incoherence of certain speeches, in e.g. *Mac-
beth*, may be of significance as expressive of deep and

disordered trains of thought; in this way a hitherto extraneous or nonaesthetic feature of the text becomes part of the play, where the play is the work of art. Secondly, we might consider the free brushwork that frequently enters into the backgrounds of Titian or Velasquez. To the eyes of contemporaries, these liberties, when not actually offensive – and we have the hostile comments of Vasari on Titian, even of Diderot on Chardin – might have had, at best, a representational justification. Even to Reynolds the merit of Gainsborough's 'handling' was that it introduced 'a kind of magic' into his painting, in that all the 'odd scratches and marks', which were individually observable close to, suddenly at a certain distance fell into place and assumed form. But since the turn that painting has increasingly taken since, say, Manet, these passages would now have a further, and more intimately aesthetic, significance for us, in their simultaneous assertion of the sensibility of the artist and the materiality of the painting. A third example is provided by Freud's analysis of Leonardo's *Virgin and Child with St Anne*. For even if on empirical grounds we reject the detail of this analysis, it leads us to take account of new sets of facts, e.g. the physiognomic similarities between two figures in a picture (in this case, the Virgin and St Anne), which it would be impossible for any modern spectator to exclude from his consideration of the representation. A simpler instance of this last type is provided by the role played in the structure of Othello by Iago's homosexuality: something which we may well believe it was not open to earlier generations to perceive.

This general point puts us in a particularly good position from which to see what is really wrong with both the Ideal and the Presentational theories of art. For both theories rest upon the assumption, shared by many

philosophers of art, that we can draw a boundary around the properties (or kinds of property) that belong to a work of art. Each theory, it will be observed, posits as the work of art an object more impoverished than the nonreflective account postulates, and it then proceeds to justify this on the grounds that the properties excluded (e.g. physical, intentional) are not of aesthetic significance. We shall, in section 52, uncover further considerations that suggest that any attempt to anticipate or prejudge the range of aesthetically significant properties is misguided.

The second respect in which the ordinary picture of interpretation and what it involves has to be modified within aesthetics is that it is not true in this area that interpretation is totally free of, in the sense of not determined by, fact. To put the matter another way, a clear separation cannot be made of fact and interpretation. For of many of the facts of art, it is required that they are interpreted in a certain way. This follows from the fact that art is an intentional activity. This point too has often been overlooked by philosophers of art.

Instructive in this respect is a recent book by Morris Weitz, *Hamlet and the Philosophy of Literary Criticism*. Weitz contends that much criticism is at fault because it ignores the crucial distinctions between description, explanation (or interpretation), and evaluation. It is only the first of these distinctions that concerns us here. For Weitz, description is whatever can be established uniquely by reference to the text: explanation is what we invoke in order to understand the text. In *Hamlet* criticism descriptive issues would be, Is Hamlet mad? Does Hamlet vacillate? Does Hamlet love his father? Did Hamlet say 'O, that this too too sullied flesh would melt'? etc. Explanatory issues would be, Is Hamlet pre-

dominantly callous? Why does Hamlet delay? Is Hamlet's emotion in excess of the facts? etc.

By dividing the issues in this way Weitz invites absurdity. For, in the first place, it must be clear that certain things are facts of *Hamlet* even though they are not in the text: for instance (to take a trivial example) that Hamlet was once a child. Equally, it is clear that certain so-called 'facts' are challengeable even though a passage in the text can be cited in support of them: for instance, Ernest Jones's interpretation is not clearly invalidated, as Weitz seems to think, by the fact that Hamlet declares his love for his father and there is no counterassertion in the text. (Cf. the insistence that the Duke in *My Last Duchess* 'never stoops' because he says he never stoops: whereas, of course, it is Browning's point that, in saying so, he does.)

Most significantly, however, Weitz is wrong to put the question why Hamlet delays on a different level from that of whether he delays: which Weitz does, simply because Shakespeare's text answers one and not the other. For it would surely be a defect in *Hamlet* if one could claim (as Eliot in effect did) that Shakespeare, in showing us that Hamlet delays, did not show us why he did. In *Hamlet* we do not simply have a random set of facts about Hamlet.

40

Let us now return to the point that despite (or perhaps because of) its importance I felt obliged to leave hanging, six sections back: namely, that it is intrinsic to our attitude to works of art that we should regard them as works of art, or, to use another terminology, that we should bring them under the concept 'art'. To some philosophers this point has seemed of such importance that the sugges-

tion has been made that instead of trying to elucidate the notions of 'art' or 'work of art' as though this were the central problem of aesthetics, we should rather define both these notions in terms of our disposition to regard things as works of art, and then make the elucidation of this disposition the topic of our efforts. In other words, a work of art is now (by definition) an object that we are disposed to regard as a work of art.

Put like this, the suggestion is obviously open to the charge of circularity: for the *definiendum* reappears in the *definiens*, moreover in a way which does not allow of elimination.

But perhaps we are wrong to take the suggestion quite so literally: that is to say, as offering us a formal definition of 'work of art'. The idea may be more like this: that the primary occurrence of the expression 'work of art' is in the phrase 'to regard x as a work of art'; that if we wish to understand the expression, we must first understand it there; and that, when it occurs elsewhere or on its own, it has to be understood by reference back to the original phrase in which it gains its meaning and from which it then, as it were for idiomatic reasons, gets detached.

If we regard this interpretation of the suggestion as the most acceptable, there is still one consequence of accepting it that needs to be pointed out: And that is that we would have to renounce the view that art is a functional concept. By a functional concept is meant a concept like 'knife', where this means (say) 'a domestic object for cutting', or 'soldier' where this means (if it ever does) 'a man for fighting'. For if 'f' is a functional concept, then to 'regard something as an f' could not be a primary occurrence of 'f'. For how we treated something when we regarded it as an 'f' would have to be dependent on the

functions that 'f's' necessarily have: and that in turn would be obtained from an understanding of the concept 'f' as it occurs outside the phrase 'regarding something as an f'. So it would be the occurrence of 'f' *tout court* that would be primary. The point is worth making, because some philosophers, perhaps implausibly, have tried to define art functionally, e.g. as an instrument to arouse certain emotions, or to play a certain social role. It must, however, be made quite clear that, even if we do reject the view that 'art' is a functional concept, we are not committed to the far more implausible though widely held view that 'all art is quite useless' – where, that is to say, this it taken quite literally as asserting that no work of art has a function. The view is quite implausible because obviously many works of art, e.g. temples, frescoes, pins, the Cellini salt-cellar, the railway station at Florence, have a function. What we are committed to is something quite different, and very much less awkward: and that is that no work of art has a function as such, i.e. in virtue of being a work of art.

However, the difficulties in the way of making the aesthetic attitude, i.e. regarding something as a work of art, constitutive of the notions of art and work of art, are not exclusively formal. Another set of difficulties concerns the aesthetic attitude itself, and what we are to understand by treating something as a work of art: a problem on which we can find, in the treatment of it by philosophers, a systematic ambiguity. This ambiguity can perhaps best be brought out by means of an interesting distinction that Wittgenstein makes.

41

In the *Brown Book* Wittgenstein notes an ambiguity in the usage of words such as 'particular' and 'peculiar'.

Let us begin, as he does, with the word 'peculiar'. Talking about a piece of soap (Wittgenstein's example) I might say that it has a peculiar smell, and then add something like 'It is the kind we used as children': alternatively I might say 'This soap has a *peculiar* smell', emphasizing the word, or 'It really has a most peculiar smell'. In the first case, the word is used to introduce the description that follows it, and indeed, when we have the description, is altogether replaceable. In the second case, however, the word is more or less equivalent to 'out of the ordinary', 'uncommon', 'striking': there is no description here whose place it takes, and indeed it is important to see that in such cases we aren't describing anything at all, we are emphasizing or drawing attention to whatever it is, without saying, perhaps without being in a position to say, what it is. This linguistic fact, which it requires some insight to discern, can be further concealed from us by a locution we might employ in these cases. Having said that the soap has a peculiar smell in the second sense, and then asked 'What smell?' we might say something like 'The smell it has', or '*This* smell', holding it up to the other's nose: and thereby think that we have done something to describe it. But, of course, we haven't. Wittgenstein calls the first usage of these words 'transitive'; the second usage, 'intransitive': and the locution that might lead us falsely to assimilate the second usage to the first he calls a 'reflexive construction'.

In the case of the word 'particular', there is a similar ambiguity of usage. The word can be used in place of a description, which we could substitute for it, sometimes only after a period of further thought or reflection. And the word can be used with no promise of such a description being forthcoming. 'Particular' used intransitively does not, it is true, carry with it the same suggestion of

uncommonness or oddity that 'peculiar' does. But it has the same function of emphasizing or concentrating upon some object or some feature of an object. Wittgenstein contrasts two usages of 'The particular way in which A enters a room . . .' by pointing out that when asked 'What way?' we might say 'He sticks his head into the room first', alternatively we might just say 'The way he does'. In the second case, Wittgenstein suggests that 'He has a particular way . . .' might have to be translated as 'I'm contemplating his movement'.

Wittgenstein thinks that it is characteristic of philosophical problems to confuse these two usages. 'There are many troubles', he writes, 'which arise in this way, that a word has a transitive and an intransitive use, and that we regard the latter as a particular case of the former, explaining a word when it is used intransitively by a reflexive construction.' He suggests that a number of difficulties in the philosophy of mind are susceptible to such an analysis.

We might now state the ambiguity referred to in the previous section by saying that philosophers of art who make reference to the aesthetic attitude are systematically ambiguous as to whether they intend a particular attitude in the transitive or the intransitive sense. On the whole, it would look as though, despite the many theories which try to give a positive characterization of the aesthetic attitude, the attitude can be conceived of as a particular attitude only in the intransitive sense: for every characterization of it in terms of some further description or set of descriptions seems to generate counter-examples.

But there is room here for misunderstanding. For it might be thought that this is the same as saying that really there is no such thing as the aesthetic attitude; or,

more mildly, that there is nothing distinctive of the aesthetic attitude. But to interpret the argument this way – which is as common among those who accept as those who reject it – is to miss its point. The point is not that there is nothing distinctive of the aesthetic attitude, but rather that there need not be any comprehensive way of referring to what is distinctive of it other than as the aesthetic attitude. In other words, we should regard Wittgenstein's argument as against what he takes to be a pervasive error in our thinking: that of identifying one phenomenon with another phenomenon more specific than it, or that of seeing everything as a diminished version of itself. It cannot be surprising that Art, which naturally provokes envy and hostility, should be perennially subject to such misrepresentation.

42

A serious distortion is introduced into many accounts of the aesthetic attitude by taking as central to it cases which are really peripheral or secondary; that is, cases where what we regard as a work of art is, in point of fact, a piece of uncontrived nature. Kant, for instance, asks us to consider a rose that we contemplate as beautiful. Or there is the more elaborate case invoked by Edward Bullough in his essay on 'psychical distance' (which is for him 'a fundamental principle' of the 'aesthetic consciousness'), where he contrasts different attitudes to a fog at sea: the various practical attitudes, of passengers or sailors, ranging from annoyance through anxiety to terror, and then the aesthetic attitude, in which we abstract ourselves from all active concerns and simply concentrate upon 'the features "objectively" constituting the phenomenon' – the veil that has the opaqueness of milk, the weird carrying-power of the air, the curious creamy

smoothness of the water, the strange solitude and re-
moteness from the world. It would be a parody of this
kind of approach, but involving no real unfairness, to
compare it to an attempt to explicate our understanding
of language by reference to the experiences we might
have in listening to a parrot 'talking'.

For the central case, which must be our starting point,
is where what we regarded as a work of art has in point of
fact also been produced as a work of art. In this way
there is a matching or correspondence between the con-
cept in the mind of the spectator and the concept in the
mind of the artist. Indeed, it might be maintained that an
error has already crept into my exposition when two
sections back I talked of the aesthetic attitude in terms of
'bringing objects under the concept "art" '; for this sug-
gests that we impose a concept upon an object, where the
other object itself is quite innocent of, or resists, that
concept. The aesthetic attitude might be thought to have
been made to look, quite misleadingly, a matter of de-
cision on our part.

This, of course, is not to deny that we can regard
objects that have not been made as works of art, or for
that matter pieces of nature that have not been made at
all, as though they had been: we can treat them as works
of art. For once the aesthetic attitude has been established
on the basis of objects produced under the concept of art,
we can then extend it beyond this base: in much the same
way as, having established the concept of person on the
basis of human beings, we may then, in fables or chil-
dren's stories, come to apply it to animals or even to trees
and rocks, and talk of them as though they could think or
feel. Such an extension in the case of art can occur tem-
porarily: as, for instance, in Valéry's famous reflection on
the sea shell. Or it can occur permanently – as, for in-

stance, in the event, which has had such far-reaching effects on the whole of modern art, when, around the turn of this century, in response to an aesthetic impulse, there was a wholesale transfer of primitive artefacts from ethnographical collections, where they had hitherto been housed, to museums of fine art, where, it was now thought, they were more appropriately located.

We can now see better the error made by Kant and Bullough in the way they introduce the aesthetic attitude. For if the aesthetic attitude can be extended, in the way I have suggested, over objects to which it does not primarily apply, then there will be a large number of objects towards which it is possible to adopt both an aesthetic and (to use the ordinary blanket term for 'non-aesthetic') a practical attitude: indeed, it is customary to say that all objects can be seen in both these modes. So it might be thought that a good method of explicating what it is to adopt an aesthetic attitude towards an object would be to take an object towards which we can adopt either attitude and then proceed to contrast the two attitudes as they bear upon this object. And so it would be: provided, of course, that, in such cases, we had a primary instance of the aesthetic attitude: and this is what Kant and Bullough do not give us. Imagine the situation in reverse: that we want to explicate what it is to adopt a practical as opposed to an aesthetic attitude towards something. It would surely be absurd to try to demonstrate what it is to show, say, concern, by concentrating on the action of the yokel who rushed up on to the stage to save the life of Desdemona.

43

In the last section I talked of an error involved in the way in which both Kant and Bullough introduce the aesthetic attitude. I did not, however, want to suggest that this was merely an error: a straightforward mistake, that and no more. For in selecting their examples as they did, these philosophers were implicitly making a point. This point might be made explicitly by saying that art is grounded in life. Not only the feelings that art is about, but also the feelings that we have about art, have their origins outside, or antecedent to, the institutions of art. If this is so, then the analogy that I have attempted to construct between, on the one hand the way in which Kant and Bullough introduce the aesthetic attitude and, on the other hand, what would obviously be an absurd way of introducing nonaesthetic or practical attitudes, must be misguided. For just because it would indeed be absurd to try to explicate the feeling of concern by reference to what one might feel in watching the misfortunes of a heroine on the stage, it by no means follows that it would be absurd to try to explicate the aesthetic attitude by reference to our contemplation of a rose or a fog at sea. What my analogy overlooked is the essential asymmetry between art and life. So, for instance, whereas we could feel concern for a real human being without ever having been affected by the depiction of misfortune in a play, the reverse is inconceivable. Equally, we could not have a feeling for the beauties of art unless we had been corresponding moved in front of nature. This is what justifies Kant's and Bullough's examples, and makes my criticism of them ineffective – the argument would run.

There is no one who has more assiduously asserted the

dependence of art and our appreciation of art upon life as we experience it than John Dewey. 'A primary task' Dewey writes (and the passage is typical)

is imposed upon one who undertakes to write upon the philosophy of the fine arts. This task is to restore continuity between the refined and the intensified forms of experience that are works of art and the everyday events, doings and sufferings that are universally recognized to constitute experience.

We can find similar assertions in many writings on the theory of art: the primacy of life over art is an idea widely attested to. The difficulty, however, is to understand or interpret the idea in such a way as to fall neither into triviality nor into error.

It would, for instance, be trivial to assert that, in the history both of the species and of the individual, experience of life precedes experience of art. Nor indeed can we imagine what it would be like for things to be otherwise. Vico, for instance, held that the earliest form of language was poetry, from which the discursive form of speech is an evolution: and a well-known theorist of our own day has suggested that there might have been a primitive language of images that preceded the ordinary language of words. Conceived of as more than allegories, such speculations rapidly lose coherence. The major difficulty is to see how these so-called languages could fulfil the basic demands of social life without in point of fact approximating to language as we have and use it. Two demands, which we might take as representative of others, are those of communication upon practical issues, and of inner thought or thinking to oneself. How could these demands be satisfied in the language postulated by Vico or Sir Herbert Read? Alternatively, it may be that these speculations require us to believe that there was an

early form of life in which such demands upon language were, as yet, not felt; to which it is hard to give sense.

The erroneous interpretation of the assertion that art is dependent upon life is more difficult to bring out. It would be to the effect that the institution of art contributes nothing to human experience, in that it merely appropriates, or annexes to itself, feelings, thoughts, attitudes, that are already in existence. Thus the disappearance of art from the world would make no substantive difference to the wealth of human life: There would be no more than a formal or superficial impoverishment: for we could concoct out of what was left an equivalent for all that we had hitherto derived from art.

The error involved in this way of interpreting the dependence of art upon life might be brought out by saying that it assumes that the value or significance of a social phenomenon can be exhaustively accounted for in terms of its bare constituents, as though the manner in which they were combined was of no relevance. To borrow the terminology of traditional empiricism, it is true that art is not (or the concept of art cannot be derived from) a simple impression. But this does not establish the superfluity of art, unless we make the further assumption (which is, it must be admitted, not all that alien to this style of philosophy) that it is only simple impressions that count.

It is clear, for instance, that, when we look at a painting or listen to a piece of music, our perception rests upon projection and responsiveness to form, processes which we may believe to be in operation from the beginnings of consciousness. It has been said, with reason, that the crux or core of art may be recognized in some effect as simple as the completely satisfying progression from a cobbled

street to the smooth base of a building that grows upward from it. Here, then, we have the dependence of art on life. But, whereas in ordinary life, or in everyday perception, such projections may go unchecked, or they need be controlled only by practical considerations, in art there is a further constraining influence of greater authority, in the person of the artist who has made or moulded the work of art according to his own inner demands. It is the imprint of these demands upon the work that we must respect, if we are to retain the aesthetic attitude. The artist has built an arena, within which we are free, but whose boundaries we must not overstep.

In a brilliant rhetorical passage in *What is Art?*, Tolstoy takes issue with the pretensions of the Wagnerites. He depicts the crowd pouring uncomprehendingly out of the darkened theatre, where they have just witnessed the third evening of the *Ring*; 'Oh yes certainly! What poetry! Marvellous! Especially the birds', he makes them exclaim – for to Tolstoy one of the perversions or sophistications of Wagner's art, one of the surest signs of his lack of inspiration or strong feeling, is his 'imitativeness' as Tolstoy calls it. But to talk of imitativeness here is to miss just the point I have been making. For when we listen to the bird songs in Wagner, even in Messiaen, we are not simply reduplicating the experiences that we might have in the woods or fields. In the aesthetic situation it is no mere contingency, as it is in nature, that we hear what we do. This does not mean, however, that what is peculiar to art is a new feeling, or a new mode of perception or a new kind of awareness; it is rather a new conjunction of elements already in existence. The perception is familiar, the sense of constraint is familiar: it is the amalgam or compound that is introduced by art.

The argument of these two sections might be illustrated historically by saying that, when the Impressionists tried to teach us to look at paintings as though we were looking at nature – a painting for Monet was *une fenêtre ouverte sur la nature* – this was because they themselves had first looked at nature in a way they had learnt from looking at paintings.

44

But, of course, it must not be assumed that, by linking the notion of regarding something as a work of art to that of producing something as a work of art, as was done a section back, any problem in aesthetic theory has been magically resolved. For the latter notion has – at any rate, there is no reason to think otherwise – as many difficulties as the former. Anthropologists and historians of culture, for instance, encounter these difficulties frequently. The hope, however, would be that by putting the two notions together, which is where they belong, it may prove possible to illuminate the difficulties of the one by reference to those attendant on the other.

More comprehensive than the question, asked about a particular object, whether it was in fact produced as a work of art, is the question, asked more generally about a society, whether objects could be produced in it as works of art, i.e. whether the society possessed the concept of art. The question is often raised about primitive societies. It has been argued by Tatarkiewicz and Collingwood that the Greeks did not possess such a concept: Paul Kristeller has further postdated the time prior to which no concept recognizably identical with ours existed, and has argued that 'art' as we employ it is an invention of the seventeenth century. Such arguments, in so far as they do not confuse the conceptual issue with the merely lexi-

cographical or verbal issue, serve to bring out the vast number of interrelated criteria that we appeal to in talking of art. It is not, therefore, surprising that in this essay the question must remain unresolved.

Another way of bringing out the ramified character of the concept of art is to take seriously for a moment Hegel's speculation that art might disappear from our world. To entertain this speculation, we have to suppose the successive disappearance of phenomena as diverse as artistic reputations, collecting, certain decisions about the environment, art history, museums, etc.: the project is immense, and is further complicated by the fact that not all these phenomena can be identified independently of each other. Many aspects of social existence would have to be unravelled to an extent that exceeds our imaginative powers. In order to understand this situation, I shall invoke another phrase from general philosophy.

45

In the mature expression of Wittgenstein's philosophy, the phrase 'form of life' (*Lebensform*) makes a frequent appearance. Art is, in Wittgenstein's sense, a form of life.

The phrase appears as descriptive or invocatory of the total context within which alone language can exist: the complex of habits, experiences, skills, with which language interlocks in that it could not be operated without them and, equally, they cannot be identified without reference to it. In particular Wittgenstein set himself against two false views of language. According to the first view, language consists essentially in names: names are connected unambiguously with objects, which they denote: and it is in virtue of this denoting relation that the words that we utter, whether to ourselves or out

loud, are about things, that our speech and thought are 'of' the world. According to the second view, language in itself is a set of inert marks: in order to acquire a reference to things, what is needed are certain characteristic experiences on the part of the potential language-users, notably the experiences of meaning and (to a lesser degree) of understanding: it is in virtue of these experiences that what we utter, aloud or to ourselves, is about the world. There are obviously considerable differences between these two views. In a way they are diametrically opposite, in that one regards language as totally adherent for its distinctive character on certain experiences, the other regards it as altogether complete prior to them. Nevertheless, the two views also have something in common. For both presuppose that these experiences exist, and can be identified, quite separately from language; that is, both from language as a whole, and also from that piece of language which directly refers to them. (This last distinction is useful, but it would be wrong to press it too hard.) The characterization of language (alternatively, of this or that sublanguage) as 'a form of life' is intended to dispute the separation on either level.

The characterization of art too as a form of life has certain parallel implications.

46

The first implication would be that we should not think that there is something which we call the artistic impulse or intention, and which can be identified quite independently of and prior to the institutions of art.

An attempt is sometimes made to explain artistic creativity (and, therefore, ultimately art itself) in terms of an artistic instinct, conceived, presumably, on the

analogy of the sexual instinct or hunger. But if we pursue the analogy, it fails us. For there is no way in which we can ascribe manifestations to this artistic instinct until there are already established in society certain practices recognized as artistic: the sexual instinct, on the other hand, manifests itself in certain activities, whether or not society recognizes them as sexual – indeed, in many cases, society actively denies their true character. To put the matter the other way round: If the sexual instincts are indulged, then certain sexual activities follow; we cannot, however, regard the arts as though we were observing in them the consequences that follow when the artistic instinct is indulged. Either way round the point is the same: in the case of sexuality, the connexion between the instinct and its satisfaction in the world is immediate, in the case of art it is mediated by a practice or institution. (If it is not always true that the sexual instinct manifests itself directly, at least the mediation is through privately determined thoughts or phantasies, not through a public institution: the parallel in the sexual sphere to talking of an artistic instinct would be to postulate a 'matrimonial' instinct.)

Nor does the more fashionable kind of analogy between the artistic instinct and disordered mental functioning, e.g. an obsession, fare any better. For, once again, there is an immediate connexion between the obsession and the compulsive behaviour in which it is discharged, to which we find no parallel in art. There may, of course, be an obsessional element in much artistic activity, but the choice by the artist of certain activities, which in point of fact happen to be artistic activities, need not be obsessional. To put it in a way that may seem paradoxical, the kind of activity in which the artist engages need not be for him, as the compulsive behaviour is of

necessity for the obsessional, 'meaningful': for on one level at any rate, the obsessional wants to do what he does, and in consequence the analysis of his obsession consists in tracing this wish to another and earlier wish, of which it is a symptom. It was just to distinguish art from this kind of case that Freud classed it as sublimation, where 'sublimation' means the discharge of energy in socially acceptable channels.

Of course, this is not to deny that art is connected with instinctual movements, or that it could exist away from their vicissitudes. There are, indeed, certain psychic forces, such as the reparative drive or the desire to establish whole objects, without which the general forms that art takes, as well as its value, would be barely comprehensible. In much the same way, religious belief would be barely comprehensible without an understanding of early attitudes to parents: but it would miss the distinctive character of such beliefs to analyse them without remainder, in the case of each individual into the personal motivation that leads him to embrace them.

The error against which this section has been directed is that of thinking that there is an artistic impulse that can be identified independently of the institutions of art. It does not follow that there is no such thing as an artistic impulse. On the contrary, there is, where this means the impulse to produce something as a work of art: an impulse which, as we have seen, constitutes, on the artist's side, the match to the aesthetic attitude, where this means the attitude of seeing something as a work of art. Indeed, reference to this impulse is necessary in order to escape from an error implicit in the very first section of this essay: that of seeing art as an unordered set of disjoined activities or products. For what gives art its unity

Art and its Objects

is that the objects that centrally belong to it have been produced under the concept of art.

47

After considering the first implication of the idea of art as a 'form of life', I shall for this section digress, and consider briefly, in the light of what has just been said, the problem which I have called (section 23) the *bricoleur* problem. For this has acquired a fresh significance. For, if it is true that artistic creativity can occur only in so far as certain processes or stuffs are already accredited as the vehicles of art, then it becomes important to know how and why these accreditations are made. More specifically, are these accreditations entirely arbitrary: in the sense, for instance, in which it is arbitrary that, out of the stock of articulated sounds, some and not others, have been appropriated by the various natural languages as their phonetic representations? Furthermore, if they are arbitrary, does this mean that the artist is dominated by whoever is responsible for the accreditations – let us for the moment identify him with the spectator – and that the picture we have of the artist as a free agent is erroneous?

I shall begin with the second question: I shall concede that there is a way in which the spectator is supreme over the artist: and I shall then try to take away the air of paradox that attaches to this truth. In the first place, we are wrong to contrast the artist and the spectator as though we were dealing here with different classes of people. For in reality what we have are two different roles, which can be filled by the same person. Indeed, it seems a necessary fact that, though not all spectators are also artists, all artists are spectators. We have already touched upon this truth in considering expression, but it

has many applications, not the least of which relates to the present problem of the social determination of art forms or art vehicles. Secondly, it is unnecessarily dramatic to speak here of 'domination': even if we do think that the accreditation of art forms is arbitrary. For we might go back for a moment to the example by reference to which I introduced the notion of arbitrariness: I did so by reference to language. Now, do we think that the native speaker of a language is 'dominated' in what he says by his predecessors and his contemporaries, in whose mouths his language has evolved to become what it now is?

We may now take up the first question and ask, Is it in fact arbitrary that certain processes and stuffs, and not others, have been accredited as the vehicles of art? It is obvious that we can make any single artistic process, e.g. placing pigment on canvas, *seem* arbitrary by stripping away from it, in our minds, anything that gives it any air of familiarity or naturalness. But all that this shows is that, when we raise questions about the arbitrariness or otherwise of a certain process, we need to specify the context in relation to which they are asked. If we indicate – as we did just now in asking about painting – a quite 'open', or zero-, context, the accreditation will clearly seem arbitrary. But it does not follow from this that it will seem arbitrary for all contexts or even for a large range of contexts.

Perhaps we can see this more clearly by going back, once again, to the phonetic problem. If we take a natural language in the abstract, it is obviously arbitrary that certain articulated sounds, not others, were chosen to be its phonemes: where this means little more than that there are others that could have been chosen. If we fill in the historical background, including the development of

language, the arbitrariness diminishes. If we complete the context and include such facts as that native speakers of one language will barely be able to form the phonemes of another, any suggestion of arbitrariness that a particular man living in a particular society might think attaches to the sounds that he employs quite vanishes. In such a situation a man can scarcely think of his language other than as, in Hamann's phrase, 'his wedded wife'.

In the case of art a natural context in which to determine the arbitrariness or otherwise of the vehicles of art is provided by certain very general principles which have historically been advanced concerning the essential characteristics of a work of art. Examples would be: that the object must be enduring, or at least that it must survive (not be consumed in) appreciation; that it must be apprehended by the 'theoretical' senses of sight and hearing; that it must exhibit internal differentiation, or be capable of being ordered; that it must not be inherently valuable, etc. Each of these principles can, of course, be questioned, and certainly as they stand none seems irreproachable. But that is not the point here: for I have introduced these principles solely to show the kind of context in which alone we can ask whether it is arbitrary that a certain stuff or process has become an accredited vehicle of art.

48

A second implication of the point that art is a form of life would be that we do wrong to postulate, of each work of art, a particular aesthetic intention or impulse which both accounts for that work and can be identified independently of it. For though there could be such a thing, there need not be.

In section 41 I invoked a distinction of Wittgenstein's

between two senses of 'peculiar' and 'particular': there to make the point that if it is characteristic of works of art that we adopt a particular attitude towards them, i.e. the aesthetic, this attitude is particular in the intransitive sense. The same distinction can be used now, this time to make a point in reference not to art in general but to individual works of art; and that is that, if we say that a work of art expresses a particular state of mind, or even if we say of it that it expresses a particular state of mind with great intensity or poignancy, once again the word 'particular' is used in its intransitive sense.

And once again this use brings with it its own dangers of misunderstanding. For if what a work of art expresses is only a particular state in an intransitive sense; or (to put it another way) if the phrase 'what the work of art expresses' is only a reflexive construction; then (it might seem) works of art do not really express anything at all. If we cannot identify the state except through the work, then we have at best poor or highly generalized expression: alternatively, we have no expression at all. This is, for instance, how Hanslick would appear to have argued, when he concluded from the fact that music doesn't express definite feelings like piety, love, joy, or sadness, that it isn't an art of expression.

But the argument is misguided. For it must be emphasized that the difference between the two usages of 'This expresses a particular state' does not correspond to any difference in the expressive function of the work, in the sense either of what is expressed or of how it is expressed. The difference lies simply in the way in which we refer to the inner state: whether we describe it, or whether we simply draw attention to or gesture towards it.

When we say *L'Embarquement pour l'Île de Cythère*

or the second section of *En Blanc et Noir*, expresses a particular feeling, and we mean this intransitively, we are misunderstood if we are then asked 'What feeling?' Nevertheless, if someone tells us that to him the painting or the piece of music means nothing, there are many resources we have at our disposal for trying to get him to see what is expressed. In the case of the music, we could play it in a certain way, we could compare it with other music, we could appeal to the desolate circumstances of its composition, we could ask him to think why he should be blind to this specific piece: in the case of the painting, we could read to him *A Prince of Court Painters*, pausing, say, on the sentence 'The evening will be a wet one', we could show him other paintings by Watteau, we could point to the fragility of the resolutions in the picture. It almost looks as though in such cases we can compensate for how little we are able to say by how much we are able to do. Art rests on the fact that deep feelings pattern themselves in a coherent way all over our life and behaviour.

49

The appeal of the view that a work of art expresses nothing unless what it expresses can be put into (other) words, can be effectively reduced by setting beside it another view, no less well entrenched in the theory of art, to the effect that a work of art has no value if what it expresses, or more generally says, can be put into (other) words.

Now, if this view had been advanced solely with reference to the nonverbal arts, it would have been of dubious significance. Or it might have been countered that the reason why a work of art not in words should not be expressible in words is just that it was not originally in

words, i.e. the view reflects on the media of art, not on art itself. However, it is a significant fact that the view has been canvassed most heavily precisely in that area of art where its cutting-edge is sharpest: in literature. For if the literature is in a language rich enough to exhibit synonomy, the view would seem to assert something about art.

Within the so-called 'New Criticism' it has been a characteristic tenet that there is a 'heresy of paraphrase'. It is, of course, conceded that we can try to formulate what a poem says. But what we produce can never be more than approximate; moreover, it does not lead us to the poem itself. For 'the paraphrase is not the real core of meaning which constitutes the essence of the poem' (Cleanth Brooks).

This view would appear to have a number of different sources. One, which is of little aesthetic interest, is that sometimes in poetry language of such simplicity or directness is used (e.g. the Lucy poems, *Romances sans Paroles*) that it is hard to see where we would start if we tried to say the same thing in other words. But not all poetry employs such language: nor, moreover, is the employment of such language peculiar to poetry. In consequence, the heresy of paraphrase, in so far as it bases itself on this consideration, is an instance of faulty generalization. Another source is that even when the poetry is in a kind of language that admits of paraphrase – metaphor would be the supreme example here – any elucidation of what the poem says would have to contain, in addition to a paraphrase of the metaphors, an account of why these particular metaphors were used. A third source is that often in poetry there is such a high degree of concentration or superimposition of content that it is not reasonable to expect that we could separate out the

various thoughts and feelings ('meanings', as they are sometimes called by critics) that are afforded expression in the work.

It is impossible in this essay to pursue these last two points, though they relate to very general and important features of art which cannot be ignored in a full understanding of the subject. One is the importance of the mode of presentation in art: a phrase which naturally changes its application somewhat as we move from medium to medium but includes very different things like brushwork, choice of imagery, interrelation of plot and sub-plots, etc. The other is the condensation characteristic of art. Both these points will be touched on later, and an attempt made to weave them into the emerging pattern of art.

50

In the light of the preceding discussion (sections 46–9), we might now turn back to the Croce–Collingwood theory of art and of the artistic process. For we are now in a position to see rather more sharply the error involved in that account. We can see it, that is, as an instance of a more general error.

For the equation, central to that theory, first of the work of art with an internally elaborated image or 'intuition', and then of the artistic gift with the capacity to elaborate and refine images in this way, is just another attempt, though perhaps a peculiarly plausible one, to conceive of art in a way that makes no allusion to a form of life. For on this theory, not only can the artist create a particular work of art without in point of fact ever externalizing it, but his capacity in general to create works of art, or his attainment as an artist (as we might put it), may flourish quite independently of there being in exist-

ence any means of externalization. The artist is an artist solely in virtue of his inner life: where 'inner life', it will be appreciated, is understood narrowly so as not to include any thoughts or feelings that contain an explicit reference to art.

The analogy with language, which the phrase 'form of life' suggests, should help us to see what is wrong here. For parallel to the conception of the artist as the man whose head is crammed with intuitions though he may know of no medium in which to externalize them, would be the conception of the thinker as a man with his head full of ideas though he possesses no language in which to express them. The second conception is evidently absurd. And if we do not always recognize the absurdity of the first conception too, this is because we do not allow the parallel. For we might rather think that the true parallel to the Crocean artist is, in the domain of language, the man who thinks to himself. But this would be wrong: for three reasons.

In the first place, the man who thinks to himself has already acquired a medium, or language. The peculiarity is in the way he employs it: that is, always internally. Secondly, it is a distinctive characteristic of language, to which there is no analogue in art (with the possible exception of the literary arts), that it has this internal employment. We can talk to ourselves, but we cannot (with the exception just noted) make works of art to ourselves. Thirdly, we must appreciate that it is an essential feature of the Croce–Collingwood thesis that not only can the artist make works of art to himself, but he may be in the situation in which he can only make works of art to himself: in other words, it is possible that he could have the intuitions and there be no way in the society of externalizing them. But there is no parallel to this in the

case of thought. For if we have language which we employ internally, then we always can, physical defects apart, also employ it externally: though in point of fact we may never do so. There could not be a language that it was impossible for someone who knew it to speak. Accordingly, the proper analogue to the artist, conceived according to the Croce–Collingwood theory, is not the thinker who has a medium of thought which he uses only to himself but the thinker who has no medium of thought, which, I have maintained, is an absurdity.

Freud, in several places, tried to approach the problem of the artistic personality by means of a comparison he proposed between the artist and the neurotic. For both the artist and the neurotic are people who, under the pressure of certain clamorous instincts, turn away from reality and lead a large part of their lives in the world of phantasy. But the artist differs from the neurotic in that he succeeds in finding 'a path back to reality'. Freud's thinking at this point is highly condensed. He would appear to have had a number of ideas in mind in using this phrase. But one of the ideas, perhaps the central one, is that the artist refuses to remain in that hallucinated condition to which the neurotic regresses, where the wish and the fulfilment of the wish are one. For the artist, unlike the neurotic, the phantasy is a starting point, not the culmination, of his activity. The energies which have initially driven him away from reality, he manages to harness to the process of making, out of the material of his wishes, an object that can then become a source of shared pleasure and consolation. For it is distinctive of the work of art, in contrast, that is, to the daydream, that it is free of the excessively personal or the utterly alien elements that at once disfigure and impoverish the life of phantasy. By means of his achievement the artist can

open to others unconscious sources of pleasure which hitherto they had been denied: and so, as Freud sanguinely puts it, the artist wins through his phantasy what the neurotic can win only in his phantasy: honour, power, and the love of women.

It will be apparent that on this account all art involves renunciation: renunciation, that is, of the immediate gratifications of phantasy. This feature is not peculiar to art, though it may be peculiarly powerful in art: it is shared with any activity in which there is a systematic abandonment of the pleasure principle in favour of the testing of wish and thought in reality. In the case of art this testing occurs twice over: first, in the confrontation of the artist and his medium, and then again in the confrontation of the artist and his society. On both occasions it is characteristic that the artist surrenders something that he cherishes in response to the stringencies of something that he recognizes as external to, and hence independent of, himself.

Now it is precisely this feature of art, art as renunciation – a feature which accounts in some measure for the pathos of art, certainly of all great art, for the sense of loss so precariously balanced against the riches and grandeur of achievement – that the theory we have been considering totally denies. The Croce–Collingwood theory of the artist is, it might be said, a testimony to the omnipotent thinking from which, in point of fact, it is the mission of art to release us.

51

Hitherto in presenting art as a form of life, I have discussed it from the artist's point of view, not the spectator's: though, of course, the two discussions overlap, as do (as I have argued) the points of view themselves.

Indeed, that they do is largely what warrants the phrase 'form of life'. However, within the form of life there is a distinctive function that accrues to the spectator: I now turn to it.

For guidance we must once again appeal to the analogy with language. What distinguishes the hearer of a language who knows it from one who doesn't is not that he reacts to it, whereas the other doesn't: for the other could, just as, say, a dog responds to his master's call. The difference is that the man who knows the language replaces an associative link, which might or might not be conditioned, with understanding. The man who does not know the language might associate to the words – or rather noises as they will be for him (see section 25). In this way he might even come to know as much about the speaker as the man who shares a language with him: but the distinctive feature is that his coming to know about the speaker and the speaker's revealing it will be two independent events, whereas the man who knows the language can't but find out what he is told.

However, how are we to use the analogy? Are we to say bluntly that it is distinctive of the spectator versed in art that he understands the work of art? Or are we to use the analogy more tentatively and say of the spectator that he characteristically replaces mere association to the work with a response that stands to art as understanding does to language?

Around the answer to this question whole theories of art (e.g. cognitive, subjective, contemplative) have been constructed. Their internecine conflict, which constitutes a large part of aesthetics, is sufficiently barren as to suggest that something has gone wrong in their initial formation. What appears to happen in most cases is this:

Something is found in our characteristic reactions to art that corresponds to *a* use of a particular word: this word is then adopted as *the* word for the spectator's attitude: but when this happens, it is the whole of the use of the word, or its use in all contexts, that is collected: and the spectator's attitude is then pronounced to be all those things which are covered by this word. A theory is established, and an insight obscured. An example is provided by Tolstoy's theory of Art. Tolstoy, recognizing that there is an element of communication in all art, or that all art is, in *some* sense of the word, communication, then said that art *was* communication, then turned his back on the original recognition by insisting that art was, or was properly, communication in some further sense of the word than that in which it had originally forced itself upon him.

What I shall do is to retain the word 'understand' to characterize the spectator's attitude, try not to import alien associations, and see what can be said about what is characteristically involved in this kind of understanding.

There are two points of a general character that it will be profitable to bear in mind throughout any such examination. I mention them here, though I shall not be able to elaborate more than a fraction of what they suggest.

The first is this: that for it to be in any way in order to talk of understanding apropos of art, there must be some kind of match or correspondence between the artist's activity and the spectator's reaction. Enough has already been said in connexion with interpretation to make it clear that in the domain of art the match will never be complete. The spectator will always understand more than the artist intended, and the artist will always have intended more than any single spectator understands – to

put it paradoxically. Nor, moreover, is it clear whether the match must be with what the artist actually did on the specific occasion of producing this particular work, or whether it has only to be with, say, the kind of thing that the artist does. Is the spectator's understanding to be directed upon the historical intention of the artist, or upon something more general or idealized? And if this element of uncertainty seems to put the understanding of art in jeopardy, we should appreciate that this is not a situation altogether peculiar to art. It is present in many cases where (as we say) we understand fully, or only too well, what someone really did or said.

Secondly, I suggest that, when we look round for examples on which to test any hypotheses that we might form about the spectator's attitude, it would be instructive to take cases where there is something which is a work of art which is habitually not regarded as one, and which we then at a certain moment come to see as one. Works of architecture that we pass daily in city streets unthinkingly are likely to provide fruitful instances. And it is significant what a very different view we are likely to get of the spectator's attitude from considering *these* cases rather than those which we are conventionally invited to consider in aesthetics (see section 42), i.e. cases where there is something that is not a work of art, which is habitually not regarded as one, and which we then at a certain point in time come to see as if it were one.

52

In section 29 I referred to a certain traditional view by saying that art in its expressive function possessed a kind of translucency: to put it another way, that if expression is not natural, but works through signs, as we may have to concede it does, then at least we may insist that these

signs are iconic. We might think that we now have an elucidation of this rather cryptic view in the idea that it is characteristic of the spectator's attitude to art that he replaces association by understanding. For, it might be argued, the difference between iconic and noniconic signs, which is generally treated as though it were a difference in the relations in which the signs stand to the referent, is really a difference in the relations in which we stand to the sign: to call a sign iconic is just to say of it that it is part of a well-entrenched or familiar language. The naturalness of a sign is a function of how natural we are with it. Now, to talk of replacing association by understanding is just to talk of a greater familiarity with the signs we use. Therefore, if we understand a sign, we can regard it as iconic, and in this way we have an over-all explanation of the iconic character of signs in art.

It would certainly seem to be true that we distinguish the cases where we 'read off' certain information from a diagram from the cases where we just see it, largely on considerations of how entrenched the medium of communication is in our life and habits. We read off the coloured picture from the black-and-white diagram, we read off the profile of the hill from the contour lines, just because these methods are so tangential to the processes by which we ordinarily acquire and distribute knowledge. However, we cannot conclude from this that any sign language that we regularly operate is for us iconic. Familiarity may be a necessary, but it is not a sufficient, condition of being iconic otherwise we should have to regard any language of which we are native speakers as *eo ipso* iconic.

If, therefore, the suggestion before us has some plausibility, this is only because, in the original argument, at least one distinction too few was made. For the im-

plication was that the distinction between cases where we 'read off' information and cases where the information is conveyed iconically is exhaustive. But this is absurd. For instance, we do not *read off* something when we *read* it.

However, even if we cannot account for the distinction between iconic and noniconic signs entirely in terms of a particular relation in which we stand to the signs, i.e. our familiarity in handling them, some advantage can be obtained from looking at it in this way if only because it attenuates the distinction. Intervening cases suggest themselves, and the peculiarity of an iconic sign is thus reduced.

Furthermore, even if we cannot analyse the distinction entirely in terms of this *one* attitude of ours toward signs, there may be *another* attitude of ours in terms of which the analysis can be completed: and in this way the original character, if not the detail, of the analysis may be preserved. Let us say that every (token) sign that we use has a cluster of properties. Ordinarily the degree of our attention to these properties varies greatly over their range: with spoken words, for instance, we pay great attention to the pitch, little to the speed. Now it may happen that, for some reason or other, we extend, or increase the scope of, our attention either intensively or extensively: we consider more properties, or the same properties more carefully. Now, my suggestion is that it is as, and when, signs become for us in this way 'fuller' objects that we may also come to feel that they have a greater appropriateness to their referent. (As a deep explanation we might want to correlate the seeing of a sign as iconic with a regression to the 'concrete thinking' of earliest infancy.) Of course, the adoption of this attitude on our part will not automatically bring it about that we

see the sign as iconic, for the properties of the sign may themselves be recalcitrant: but it can be contributory towards it. However, once we have seen the sign as iconic through an increasing sensitivity to its many properties, we then tend to disguise this by talking as though there were just one very special property of the sign, that of being iconic, of which we had now become aware. We think that the sign is tied to its referent by one special link, whereas in point of fact there are merely many associations.

(I have, it will be observed, followed the convention whereby an iconic sign is thought of as matching, or resembling, or being congruent with, its *referent*: but why referent or reference, rather than *sense*, is left unexamined – as, for reasons of space, it will be here.)

I want to complete the present discussion by suggesting that it is part of the spectator's attitude to art that he should adopt *this* attitude towards the work: that he should make it the object of an ever-increasing or deepening attention. Here we have the mediating link between art and the iconicity of signs. Most significantly, we have here further confirmation for the view, already insisted upon (section 39), that the properties of a work of art cannot be demarcated: for, as our attention spreads over the object, more and more of its properties may become incorporated into its aesthetic nature. It was some such thought as this that we may believe Walter Pater to have intended when he appropriated the famous phrase that all art 'aspires to the condition of music'.

53

Mozart—his father: Vienna, 26 September 1781.

... As Osmin's rage gradually increases, there comes (just when the aria seems to be at an end) the allegro assai, which

is in a totally different tempo and in a different key: this is bound to be very effective. For just as a man in such a towering rage oversteps all the bounds of order, moderation and propriety and completely forgets himself, so must the music too forget itself. But since passions, whether violent or not, must never be expressed to the point of exciting disgust, and as music, even in the most terrible situations, must never offend the ear, but must please the listener, or in other words must never cease to be *music*, so I have not chosen a key remote from F (in which the aria is written) but one related to it – not the nearest, D minor, but the more remote A minor.

There is here, not far below the surface, a clue to something which we have perhaps ignored, or at any rate underestimated, in connexion with the problems raised in the last section: more generally, in connexion with expression. For what Mozart's letter brings out is the way in which the attribution of expressive value or significance to a work of art presupposes an autonomous activity, carried out over time, which consists in the building up, in the modifying, in the decomposing, of things which we may think of as unities or structures. A precondition of the expressiveness of art is – to appropriate the title of a famous work in general art history – the 'life of forms in art'. This phrase should not lead us, as perhaps it did Henri Foçillon, who coined it, to assign a kind of impetus or quasi-evolutionary efficacy to the forms themselves, distinct from human agency. On the contrary, it is always the artist who, consciously or unconsciously, shapes the forms that bear his name. (Indeed, nothing less than that would suit my point.) Nevertheless the artist does not conjure these forms out of nothing: nor do we have to maintain that he does so in order to attribute agency to him. In creating his forms the artist is oper-

ating inside a continuing activity or enterprise, and this enterprise has its own repertoire, imposes its own stringencies, offers its own opportunities, and thereby provides occasions, inconceivable outside it, for invention and audacity.

A parallel suggests itself. In recent years our knowledge of the emotional life and development of children – and hence of adults in so far as we all retain infantile residues – has increased beyond anything believed feasible forty or fifty years ago, through the exploitation of an obvious enough resource: the play of children. By observing and then interpreting how children play it has proved possible to trace back certain dominant anxieties, and the defences that are characteristically invoked against them, to the earliest months of infancy. But such observation has in turn proved possible only because of the inherent structure that games possess and that the child twists and turns to his own needs. There is, we may say, a 'life of forms in play'.

So, for instance, we say that play is inhibited when the child's interest in a doll consists solely in dressing and undressing it, or when the only game it can play with toy trains or cars consists in accidents or collisions, just because we are aware that these games admit of further possibilities, which the child is unable to utilize. Or, again, we argue that the child is anxious when it moves continuously from playing with water, to cutting out in paper, to drawing with crayon, and back again, just because these activities have already been identified as different games. If the structure of play is not explicitly referred to in psychoanalytic writing, this can only be because it seems such an obvious fact. Yet it is in virtue of it that we are enabled to assign to the child such a vast range of feelings and beliefs – frustration, envy of the

mother, jealousy, guilt, and the drive to make reparation.

I am not saying that art is, or is a form of, play. There is a view to this effect, deriving from Schiller and then lost in vulgarization in the last century. Here I compare art and play, only to make a point about art analogous to that I have been asserting about play: namely, that art must first have a life of its own, before it can then become all the other things that it is.

This point, about the priority or autonomy of art's own procedures, was made by the psychoanalyst Ernst Kris, and in a way which allows us a further insight into its significance. Kris put it by saying that in the creation of a work of art the relations of the primary and the secondary processes are reversed from those revealed in the study of the dream. The terms need explication. In *The Interpretation of Dreams*, Freud was driven to conclude that two fundamentally different types of psychical process can be discriminated in the formation of dreams. One of these, which also accounts for our ordinary thinking, issues in rational trains of thought. The other process, which is the survival of our earliest mental apparatus, seizes hold of this train of thought and operates upon it in certain characteristic ways: the ways which Freud singled out for scrutiny are condensation, displacement, and the casting of thought into a visually representable form. The more primitive of the two processes Freud called the primary process: the other, the process of rationality, he called the secondary process: and as to their interrelations, Freud formed the hypothesis that a train of thought, which is the product of the secondary process, is subjected to the operations of the primary process when and only when there has been transferred on to it a wish to which expression is denied.

The result of these interrelations, or the dream, is a kind of picture-puzzle, unintelligible in itself, in which the various latent thoughts constituting the wish are represented in a pictographic script, to be deciphered only after the most careful analysis.

The work of art has this in common with the dream: that it draws upon powerful unconscious sources. But it is unlike the dream in that even at its freest it exhibits a vastly greater measure of control, and Kris' suggestion is that if we want an analogue for artistic creation we should find it in the formation not of dreams but of jokes. For in *Jokes and the Unconscious* Freud had proposed a somewhat different relation as holding between the primary and the secondary processes when a joke is formed. Freud expressed this by saying that a joke comes into being when a preconscious thought is 'given over for a moment' to unconscious revision. Jokes, like dreams, have some of the characteristics of our earliest mode of thinking. (It was, Freud pointed out, no coincidence that many people, confronted for the first time with the analysis of a dream, find it funny or in the nature of a joke.) At the same time, whereas a dream is asocial, private and eludes understanding, a joke is social, public and aims at intelligibility. And the explanation of these differences – along with what the two phenomena have in common – lies in the relative influence of the two psychic processes. A dream remains *au fond* an unconscious wish that makes use of the secondary process in order to escape detection and to avoid unpleasure: a joke is a thought which takes advantage of the primary process to gain elaboration and to produce pleasure. On this level, the work of art resembles the joke, not the dream.

It is not necessary to accept the precise way in which Kris goes on to demarcate the primary and secondary

processes in order to benefit from his suggestion. For what it permits us to see is the necessity, for art's expressiveness, indeed for its achievements in general, that there should be certain accredited activities with stringencies of their own, recognized as leading to works of art, upon which the secondary process operates. We could not make jokes unless there was, in general, language; more particularly, something that we had to say in that language. By contrast, dreams lack such presuppositions.

But the comparison between jokes as Freud explained them and works of art allows us to see more than this. It allows us to see yet another thing that is wrong in the Croce–Collingwood theory: and that is the extent to which the theory distorts or disguises what occurs at the moment of 'externalization'. For that is the moment at which, in Freud's words, the thought, or the project that lies behind the work of art, is 'dipped in the unconscious'. Without such an immersion, the elaboration that makes for much of the depth of the work of art would be missing.

Again, the assimilation of works of art to jokes rather than to dreams restores to its proper place in aesthetic theory the element of making or agency appropriate to the artist. For, as Freud points out, we 'make' jokes. Of course we do not – as he goes on to say – make jokes in the sense in which we make a judgement or make an objection. We cannot, for instance, decide to make a joke, nor can we make a joke to order. Similarly, as Shelley pointed out, 'a man cannot say "I will compose poetry" ': but it does not follow from this that the poet does not compose poetry. In a clear sense he does. There is, however, no sense at all in which we can say that we make our dreams.

54

Certain remarks I have made apropos both of artistic creativity and of aesthetic understanding, might seem to endorse a particular view in the psychology of art: namely, that art consists in the manufacture of certain artifacts which are conceived of and valued, by artist and spectator alike, as preeminently independent and self-subsistent objects. The significance of a work of art (would be the view) lies in its oneness. A great deal both of traditional aesthetics and of psychoanalytic writing converge on this point.

Now, it is certainly true that the affirmation and celebration of the whole object plays a great part in art. As the representative of the good inner figure, of the parent assaulted in phantasy and then lovingly restored, it is essential to all creative activity. There are, however, other feelings and attitudes that are accommodated, or to which we find correspondences, in those complex and multifarious structures which we designate works of art. In a brilliant series of essays Adrian Stokes has drawn our attention to the enveloping aspect of art, the 'invitation' as he calls it, which is in danger of being overlooked by those who concentrate upon the self-sufficiency of the work of art. And this aspect of art has its deeper explanation too. Before we can experience the good or restored parent as a whole figure, we must first be able to establish relations of a stable and loving character with parts of the parent's body, felt as benign influences. Without such part-object relations the whole-object relation would never be achieved, and it is Stokes' contention that it is these earlier psychic states that certain forms of art – and Stokes is here thinking explicitly of the painterly style, or of art in the plastic rather than in the carving

tradition, as well as much modern art – invite us to re-experience.

It would not be appropriate here to follow these speculations in detail. For that would take us out of the philosophy of art into its psychology or phenomenology. The point I want to make is more general. It is that an inadequate or a diminished view of our actual experience of art can in turn suggest, or reinforce, a false theoretical conception of art. Indeed, we are already in a position to see this at work. For if we take a certain broad philosophical characterization of the aesthetic attitude – as, for instance, it is defined by Kant in terms of disinterestedness, or by Bullough in terms of psychical distance, or (perhaps) by Ortega y Gasset in terms of dehumanization – we may interpret this as the reflection of a one-sided concern with the work of art as an independent and self-sufficient object. All these philosophers, we may say, were only able to envisage the aesthetic attitude as exemplifying a whole-object relation.

Nor need we stop here. For we can extend our interpretation from the adherents of a certain tradition to its critics. In *Abstraction and Empathy* Wilhelm Worringer, while explicitly attacking the empathists, in effect questioned the presuppositions of a whole continuing way of regarding and evaluating works of art. Under the guise of theory a specific preference for one form of aesthetic experience had (he claimed) been erected into an absolute or timeless norm. 'Our traditional aesthetics', he wrote in 1906, 'is nothing more than a psychology of the Classical feeling for art.' In the present setting it is instructive to examine Worringer's characterization of the other form of art or aesthetic experience, the 'transcendental' as he called it: which he particularly connected with the art of primitive peoples and the Gothic. The

psychic state from which such art springs is, at any rate by the standards of 'the classical mind', deficient in awareness both of the self and of clearly defined external objects. The art that attempts to appease this state does so by setting up a point of rest or tranquillity over and against the oppressive flux of appearances. We need not (even if we can) follow Worringer in all that he says. But it is possible to see in his rather murky analysis a characterization – although ironically enough, an inadequate or one-sided characterization – of those early psychic states to which Stokes' essays make many references.

55

The analogy between art and language has now been considered first, from the point of view of the artist, who may be compared to the speaker of a language, then, from the point of view of the audience or spectator, who may be compared to the person who hears or reads a language. Conversely, I have tried to see how far the notions of meaning something and of understanding may be applied to art. However, recent philosophy suggests a third point of view from which the analogy may be considered. In the *Philosophical Investigations* Wittgenstein showed how the concept of a language and what it involves may be understood, or our understanding of it deepened, by considering how we learn language. The suggestion, therefore, would be that we should consider our analogy from the point of view of someone learning either language or art. Is there a resemblance between the way in which language is acquired and the way in which art is acquired? A more fundamental inquiry might be, Does the process of learning art tell us anything about the nature of art, in the way in which the process of learning a language does tell us something about the nature of language?

I shall not answer this question: upon which the issues raised in section 52 evidently bear. I shall merely make an observation, which in turn may suggest how the question is to be answered. In the *Philosophical Investigations* Wittgenstein insists that if we try to find out about the nature of language by considering how someone learns a language, we must not (as St Augustine did) take the case of the person learning his native language. In discussing iconicity I came close to talking of what would be the equivalent in art of the native speaker of a language. I stopped short: why I stopped short is, perhaps, because there *is* no equivalent.

56

The analogy that I have been pursuing through these later sections is, I want to insist, one between art and language. The insistence is necessary: for there is another analogy, which bears a superficial resemblance to mine, and which may, deliberately or in error, be substituted for it. That is the analogy between art and a code. Either it may be specifically held that art has more in common with a code than with a language: or else the original analogy may be adhered to, but the characteristic features of a language and a code may become so confused or transposed, that in point of fact it is to a code, not to language, that art is assimilated. In either case error ensues. (For these purposes a code may be defined as the representation, or mode of representation, of a language. With, of course, this proviso: that there is not a one-one correspondence between languages and codes. Semaphore would be an example of a code: so also, though less obviously, would be the alphabetic inscription of English or French.)

I want to consider two ways in which these analogies

may become confused, or the one substituted for the other. The first, which is straightforward, raises again the issues of understanding and paraphrasability. It is an essential; not a contingent, feature of a code that, if we claim to understand a coded message, and are then asked what it says, we should be able to say. We could not understand a message in a code unless we were able to decipher it or to formulate it *en clair*. Accordingly, if we assimilate art to a code, then we will find ourselves thinking (falsely, as we have seen) that our understanding of a work of art will be adequate only to the degree to which we can paraphrase it, or can say what we understand by it. Conversely, we may now say that when Hanslick rejected the expressiveness of music, he did so because he found cogent an argument which implicitly treated music as, or presupposed music to be, a code rather than a language.

The confusion between language and a code, alternatively the deliberate assimilation of art to a code, also occurs – though more obscurely – when certain attempts are made to apply information theory, which was after all worked out in connexion with the study of telegraphic or telephonic channels, to the problems of aesthetics. I am specifically thinking of the attempts to invoke the notion of redundancy to explain, on the one hand, meaning, on the other hand, coherence or unity, as they occur in art. I wish to maintain that any such enterprise, in so far as it goes beyond mere suggestion or metaphor, rests upon the assimilation of art to a diminished version of language, and hence to a diminished version of itself.

In scanning a linear message, we may be able on the basis of one sign or element to infer, to some degree of probability, what the next sign or element will be. The higher the probability, the more unnecessary it is, given

the first sign, for the second sign to be set down. The superfluity of one sign on the basis of a preceding sign is called redundancy, which in turn admits of degree. In inverse ratio to a sign's redundancy is the information it carries. If a sign is 100 per cent redundant, it carries no information, since its occurrence can be totally predicted; however, as its redundancy or degree of probability decreases, so the information that it carries increases. If we now try to use these notions to explicate the aesthetic notions of meaning and unity, we shall say the following: The conditions in which an element of a work of art gives rise to meaning are the same as those in which information is carried, i.e. the conditions increase in favourability as redundancy approaches zero. By contrast, the conditions in which a work of art gains in unity are the same as those in which redundancy is increased: for our awareness of a pattern unfolding is coincident with a large number of our expectations being realized.

I now wish to maintain two points. First, that the notion of redundancy applies much more readily or extensively to the representation of a language than to a language itself. This contention does not, of course, directly bear upon the aesthetic issue: but it has a negative force, in that it removes one argument, based on analogy, for thinking that the notion of redundancy is central to art. Secondly, I want to argue, more directly, that the notion of redundancy has only a peripheral application to art.

To apply the notion of redundancy presupposes that we are dealing with what may generally be thought of as a probabilistic system: a system, that is, where we are able on the basis of one sign or set of signs to make a preferred guess as to the subsequent sign or signs. If we

now wish to establish whether it is a language or its representation, i.e. a code, that most adequately satisfies such a model, we must first consider what are the factors that would justify us in assigning transition probabilities between successive elements in a message. Roughly, there would seem to be two kinds of determinant: syntax or formation rules, and empirical frequencies. I shall not try to assess the comparative role in a code and in language of syntactical constraints over the sequence of elements: though we may already remark a significant difference in the fact that the elements or alphabet of a code are denumerable, whereas no precise limit can be set to the vocabulary of a language. But if we turn to statistical frequencies, the difference in the use that can be made of these in the two cases, seems to be one of principle. For though it may be possible to use statistical material to assign a probability to the successor of some specified code element, the corresponding assumption that would have to be employed in respect of language seems quite unwarranted: namely, that the employment of a given string of words makes probable its reemployment.

As for any direct argument to the effect that art, or any essential feature of it, can be explicated in terms of redundancy, the case seems even weaker. And there are three considerations that weigh against it.

In the first place, the notion of redundancy presupposes linearity. There must be a specified sense or direction in which the work of art is to be read: and it is only in the temporal kinds of art that such a direction can be unambiguously posited. Secondly, if it runs counter to the creative character of language to assume that the higher the occurrence of a certain sequence, the higher the probability of its recurrence, the corresponding assumption about art must be even less well

founded. Of course, there are areas of art where we find very marked stringencies as to the sequence of elements: I am thinking of the rules of melody, or poetic metre. But these stringencies cannot be equated with probabilities based on frequency. For it is only if the stringencies have been adopted, that we shall find the corresponding constraints exemplified: equally, it is only if we know that the stringencies have been adopted, that we are justified in modifying our expectation to anticipate them. Thirdly (and the last sentence suggests this point), even if it were possible, to explain meaning or coherence in art in terms of redundancy, mere redundancies, even rule-governed redundancies, would not suffice: we should require felt or experienced redundancies. Not every redundancy generates a corresponding expectation; nor is it any part of the understanding of art that we should be equally aware of, or attentive to, all transitions that exhibit high frequency. A central question in the psychology of art is why some redundancies give rise to expectations, and others do not.

Equally, it must be pointed out that not every expectation in art is based on redundancy. We may expect Mozart to treat a theme, or van Eyck to order a mass of detail, in a particular way, but we could not formulate this in terms of past performances. Those who are hopeful of the application of information theory to the problems of art tend to talk of styles or conventions as 'internalized probabilistic systems'. That is consonant with their approach. In *Renaissance and Baroque* Wölfflin is sharply critical of the theory, there attributed to Göller, that the great changes of style can be attributed to tedium or a jaded sensibility. If the foregoing characterization of style were acceptable, there would be much to be said for Göller's theory.

57

I have, then, been trying to elucidate the notion of art as a form of life by pursuing the analogy that the phrase itself intimates: that with language. However a point is reached at which the analogy runs out. I want in this and the subsequent section to touch on two important limitations that must be set upon it.

But, first, an objection to the analogy as such, which I mention solely in order to get it out of the way. It might be argued that art cannot be compared to language in that the two differ radically in function: for the function of language is to communicate ideas, whereas the function of art is something quite different, e.g. to arouse, express, evoke emotions, etc. Alternatively, it is the function of *one* of the two uses of language, i.e. the scientific, to communicate ideas, though it is the function of the other use, i.e. the poetic, to express emotion, and the analogy is therefore ambiguous in a significant respect, in that it does not state which of the two uses of language is intended. But the theory that language is essentially concerned with the communication of ideas is a dogmatic notion, which does not even take account of the variety of ways in which ideas are communicated. However, the theory of the two uses of language (as in the critical theory of I. A. Richards) constitutes no real improvement on it, incorporating as it does the original error: for it would never have been necessary to postulate the poetic use if the account of the scientific use had not been taken over unexamined from the theory of the single use.

However, a related point constitutes the first of the genuine limitations to the analogy. To compare art to language runs into the difficulty that some works of art, more generally some kinds of work of art, e.g. poems,

plays, novels, are actually in language. In the case of the literary arts, does the analogy simply collapse into identity? Or are we to observe here a difference in level, and say that literary works of art at one and the same time are like linguistic structures and also have as their components linguistic structures?

There certainly seems no easy way of deciding whether it is fruitful to persist in the analogy over the range of the literary arts. In view of the way we have been using the analogy, it looks as though the crucial question to ask would be, Is there a special sense in which we could be said to understand a poem or a novel over and above our understanding of the words, phrases, sentences, that occur in it? But it remains unclear how this question is to be decided. For instance: If it is asserted, as it is in the New Criticism, that understanding poetry is grasping a certain structure of metaphors, is this tantamount to giving an affirmative answer to this question?

58

The second limitation that must be placed on the analogy between art and language is more pervasive, in that it operates across the whole range of the arts: and that is, the far higher degree of tolerance or permissibility that exists in art. In language, for instance, we can recognize degrees of grammaticality, or we distinguish between those statements to which a semantic interpretation is assigned, those where one may be imposed, and those where no such interpretation is feasible. It is evident that, though works of art can become incoherent, it is impossible to construct a set of rules or a theory by reference to which this could be exhibited.

At the risk of obviousness it must be emphasized that

what we have encountered here is a defect in a certain analogy between art and something else, not a defect in art itself. It would be wrong, for instance, to think that art exhibits to a high degree something that language tolerates only to a low degree, i.e. what we might think of as 'vagueness'. To counteract this temptation we need to see the positive side to the indeterminacy possessed by art: more specifically, how this indeterminacy accommodates, or brings to a convergence, demands characteristically made of art by the spectator and demands characteristically made of art by the artist. We already have surveyed some material that bears upon this.

From the spectator's point it is, as we have seen (section 38), required that he should be able to structure or interpret the work of art in more ways than one. The freedom in perception and understanding that this allows him is one of the recognized values that art possesses. But this freedom is acceptable only if it is not gained at the expense of the artist: it must, therefore, be congruent with some requirement of his.

To identify this requirement, we need to realize that, at any rate over a great deal of art, the artist is characteristically operating at the intersection of more than one intention. It would, therefore, be quite alien to his purposes if there were rules in art which allowed him to construct works which could be unambiguously correlated with a 'meaning': whether this meaning is envisaged as an inner state or a message. For it would be of no interest to him to construct such works: or, to put it another way, his distinctive problem would always consist in the fusion or condensation of works constructed in this way.

A misleading way of putting the preceding point would be to say that all (or most) art is 'ambiguous'. Mis-

leading: because it suggests that the intentions whose point of intersection is a work of art are of the same type or order: for instance, that they are all meanings. But it needs to be appreciated that very often the confluence will occur between a meaning and, say, a purely 'formal' intention. By a formal intention I mean something like the desire to assert the materiality or physical properties of the medium: alternatively, an intention connected with the tradition, in the sense of wanting to modify it, or to realize it, or to comment upon it.

It is instructive to reflect how little any of these considerations arise in an area that is often in philosophy bracketed with art, i.e. morality. Once this is appreciated to the full it should cause little surprise that, whereas morality is rule-dependent, art isn't.

59

In the last section the word 'incoherent' was introduced in connexion with defective works of art, and it might be thought an error that this was not taken up, since it would have provided us with a means towards the solution of our problem. For do we not have here a concept for characterizing deviation in the domain of art, analogous to that of ungrammaticality or nonsense as applied to language?

The suggestion is attractive: incorporating, as it does, an ancient idea, at least as old as Aristotle, that the peculiar virtue of a work of art consists in its unity, or the relation of parts to whole. There are, however, certain difficulties that emerge in the course of working out this suggestion, which somewhat detract from its *prima facie* utility.

The appeal of the suggestion lies in the idea that we can straightforwardly equate the coherence demanded of

works of art with some clear-cut concept of order as this has been systematically developed in some adjacent theory: for instance, with mathematical concepts of symmetry or ratio, alternatively with the concept of *Gestalt* as this occurs in experimental psychology. The trouble, however, is that any such equation yields us at best a characterization of certain versions, or historical variants, of the coherence demand: it does not give us a universal account. It allows, for instance, for the Renaissance notion of *concinnitas*, which was, significantly enough, developed with a mathematical model explicitly in mind: it will not, however, allow for the types of order that we find exemplified in many of the great Romanesque sculptural ensembles or, again, in the work of late Monet or Pollock.

There are a number of considerations that account for this inadequacy. In the first place, the coherence that we look for in a work of art is always relative to the elements that the artist is required to assemble within it. (The requirement may, of course, originate either externally or internally to the artist.) In this way all judgements of coherence are comparative: that is to say, the work of art is pronounced to be more coherent than it might otherwise have been, given its elements, alternatively more coherent than some other arrangement of those same elements.

Secondly, there are likely to be considerable differences in weighting between the different elements, so that whereas some elements are treated as highly malleable and can be adjusted at will, to fit the demands of composition, other elements are comparatively intractable and their original characteristics must be safeguarded. An example of a somewhat superficial kind comes from the *Madonna della Sedia* where, it has been pointed out,

Raphael, confronted by the possibility of having two adjacent circular shapes on his canvas, preferred to flatten out the knob of the chair back rather than distort the eye of the Infant Christ: in acting thus he was implicitly accepting a certain evaluation concerning the integrity of his elements. It is arguable that the Morellian schedules of hand, ear, finger, are defective from the point of view of scientific connoisseurship, just because they fail to recognize the existence of such constraints upon the artist.

Thirdly, the elements themselves will not always be homogeneous as to type or matter. For instance, in certain Braque still-lifes from 1912 onwards the elements to be ordered will include the profiles of the various objects that constitute the still life and also the materiality of the picture surface. It is, indeed, necessary to appreciate the very wide range of elements that are characteristically assembled in works of art, if we are to see why there always is a problem of order in art. Equally, this enables us to see why the argument, which originates with Plotinus, that beauty cannot consist in organization because, if it did, we would not be able to predicate beauty of totally simple objects, is vacuous in its application to art. For within art there will be (virtually) no such cases.

The foregoing considerations alone would account for the very limited utility of introducing strict or systematic notions of order or regularity in the explication of artistic order. But to them we can add another consideration, whose consequences are far-reaching indeed. And that is that in many instances, the kind of order that is sought by the artist depends from historical precedents: that is, he will assemble his elements in ways that self-consciously react against, or overtly presuppose, arrangements that have already been tried out within the tradition. We might call such forms of order 'elliptical',

in that the work of art does not, in its manifest properties, present us with enough evidence to comprehend the order it exhibits. This is, of course, something to be met with more at certain historical periods than others. It is no coincidence that the art-historical term which we use to characterize a period when this phenomenon was most in evidence, 'mannerism', has a twofold meaning: it connotes at once erudition concerning the past, and a deep preoccupation with style.

60

Enough has already been said in this essay to suggest that our initial hope of eliciting a definition of art, or of a work of art, was excessive: to suggest this, though not to prove it. However, it may anyhow be that a more fruitful, as well as a more realistic, enterprise would be to seek, not a definition, but a general method for identifying works of art, and, in the concluding consideration of the preceding section, there is an indication how this might be obtained. For the method might take this form: that we should, first, pick out certain objects as original or primary works of art; and that we should then set up some rules which, successively applied to the original works of art, will give us (within certain rough limits) all subsequent or derivative works of art.

A strong analogy suggests itself between such a recursive method of identifying works of art and the project of a generative grammar in which all the well-formed sentences of a language are specified in terms of certain kernel sentences and a set of rewrite rules. The major difference between the two enterprises would be that, whereas the derivations of which a grammar takes account are permissible or valid derivations, the transformations to which a theory of art needs to be adequate are

those which have been made over the ages: identifiable works of art constitute a historical not an ideal, set.

It is a corollary of this last point that if we could lay down the rules in accordance with which the historical derivations have been made, we should have a theory which not merely was comprehensive of all works of art, it would also give us some insight into their formation.

But can we arrive at a formulation of these rules? It is important that at the outset we should be aware of the immensity of the task. It is, in the first place, evident that it would be insufficient to have rules which merely allowed us to derive from one work of art another of the same, or roughly the same, structure. We may regard it as the persistent ambition of Academic theory to limit the domain of art to works that can be regarded as sub-stitution-instances of an original or canonical work: but this ambition has been consistently frustrated.

Of course, there are historical derivations that have been of this simple form, e.g. the changes in sonnet form which comprise much of the history of early Renaissance literatures. But as we move out from this narrow base, we encounter increasing complexity. The next cases we might consider are those which involve the embedment, total or partial, of one work of art in another. The simplest example here is that of allusion or quotation: a more complex instance, cited by I. A. Richards in *The Principles of Literary Criticism*, is provided by the second chorus of *Hellas*, where we have, as Richards puts it, a borrowing by Shelley of Milton's 'voice'.

There are, however, a substantial number of trans-formations in the domain of art which are more radical still, and require for their understanding rules much stron-ger. Such transformations consist in nothing less than the deletion of the principal characteristics of earlier art,

effected either instantaneously or serially over time. Examples of such metamorphoses would be the great stylistic changes, as these have been studied by those 'philosophical' art-historians who have sensed most clearly the essentially transformational character of art, e.g. Wölfflin, Riegel, Foçillon. It would be possible to interpret these powerful thinkers as attempting to formulate the recursive devices whereby art proceeds. Their actual achievement was subject to three limitations. In the first place, they had far too narrow a conception of the range of devices operative in art: symptomatic of this would be, for instance, Wölfflin's failure to account for, or, for that matter, to see that he had to account for, Mannerism in his stylistic cycle. Secondly, they had no theoretical means of fitting together stylistic changes on the general or social level with changes of style on an individual or expressive level: Wölfflin's famous programme of 'art history without names' is in effect the denial that there is any need to make the fit since all change occurs primarily or operatively on the more general level. Thirdly, all these writers were confused about the status of their investigation. From the fact that it is in the nature of art that it changes or has a history, they tried to move to the conclusion that the particular history it has, the particular changes it undergoes, are grounded in the nature of art.

It would seem to be a feature of contemporary art that the transformations it exhibits are more extensive in character than the stylistic changes with which the philosophical art-historians concerned themselves. For it is arguable that whereas the earlier changes affected only the more or less detailed properties of a work of art, e.g. painterly versus linear, in the art of our day one work of art generates another by the supersession of its most gen-

eral or its all-over properties, e.g. Pont-Aven as the successor of Impressionism, hard-edge painting as the successor of abstract expressionism.

There are two general problems that arise in connexion with the devices in terms of which I have suggested that the history of art might be set out. These problems are very difficult, and I shall simply mention them. The first concerns the nature of these devices. Are they theoretical postulates made by the art-historian in order to explain the course of art, or do they enter more substantively into the activity of the artist, say as regulative principles either conscious or unconscious? Perhaps this distinction need not be too sharp. We have seen that it is characteristic of the artist that he works under the concept of art. In any age this concept will probably belong to a theory, of which the artist may well be unaware. It then becomes unclear, perhaps even immaterial, whether we are to say that the artist works under such a theory.

Secondly, How much of art should we hope to account for in this way? In linguistic theory a distinction is made between two kinds of originality: that to which any grammatical theory must be adequate, which is inherently rule-abiding, and that which depends on the creation of rules. It would be paradoxical if originality of the second kind did not also exist in art.

61

In the preceding section I have indicated some kind of scheme of reference, or framework, within which a work of art can be identified. This does not, of course, mean that any spectator, who wishes to identify something as a work of art, must be able to locate it at its precise point within such a framework. It is enough that he should

have an acquaintance with that local part of the frame-
work where the work occurs: alternatively, that he
should be able to take this on trust from someone who
satisfies this condition.

A far more difficult problem arises concerning the re-
lation between the conditions necessary for identifying a
work of art and those necessary for its understanding. To
what extent do we need to be able to locate the work of
art in its historical setting before we can understand it?
The answer that we give to this question is likely to vary
from one work of art to another, depending upon the
extent to which the formative history of the work actu-
ally enters into, or affects, the content: to put it another
way, the issue depends on how much the style of the
work is an institutional, and how much it is an express-
ive, matter. As a rough principle it might be laid down
that those works of art which result from the application
of the more radical transformational devices will require
for their understanding a correspondingly greater aware-
ness of the devices that went to their formation.

Two examples may serve to make this last point. Mer-
leau-Ponty suggests that much of the dramatic tension of
Julien Sorel's return to Verrières arises from the sup-
pression of the kind of thoughts or interior detail that we
could expect to find in such an account; we get in one
page what might have taken up five. If this is so, then it
would seem to follow that, for the understanding of this
passage, the reader of *Le Rouge et le Noir* needs to come
to the book with at any rate some acquaintance with the
conventions of the early-nineteenth-century novel. The
second example is more radical. In 1917 Marcel Du-
champ submitted to an art exhibition a porcelain urinal
with the signature of the manufacturer attached in his,
Duchamp's, handwriting. The significance of such icono-

clastic gestures is manifold; but in so far as the gesture is to be seen as falling within art, it has been argued (by Adrian Stokes) that this requires that we project on to the object's 'patterns and shape ... a significance learned from many pictures and sculptures'. In other words, it would be difficult to appreciate what Duchamp was trying to do without an over-all knowledge of the history of art's metamorphoses.

We can also approach the matter the other way round. If there are many cases where our understanding of a work does not require that we should be able to identify it precisely, nevertheless there are very few cases indeed where our understanding of a work is not likely to suffer from the fact that we misidentify it, or that we falsely locate it from a historical point of view. It is in this respect instructive to consider the vicissitudes of appreciation undergone by works that have been systematically misidentified, e.g. pieces of Hellenistic sculpture that for centuries were believed to have a classical *provenance*.

62

The argument of the preceding section appears to dispute a well-entrenched view about art: for it suggests that it is only works of art that come above – whereas, on the ordinary view, it is those works which fall below – a certain level of originality or self-consciousness, which need or can acquire a historical explanation. Now, in so far as the ordinary view is not mere prejudice, the dispute may be based upon a misunderstanding. For the kind of explanation I have been talking of is, it will be observed, one in purely art-historical terms, whereas what is ordinarily objected to is a form of explanation which would see the work of art as the product of extraartistic conditions. It is not historical determination as such, it is

(more specifically) social determination, that is thought incompatible with the highest values of art: spontaneity, originality, and full expressiveness.

The question that now arises, whether social determination is in fact incompatible with these values, is hard to answer: largely because it presupposes a clearer or more precisely formulated notion of social determination than is generally forthcoming from either the adherents or the critics of social explanation.

It is evident that, if one reads into the notion of social determination something akin to compulsion, or generally of a coercive character, then it will follow that explanation in social terms and the imputation of the highest expressive values are incompatible. And certainly some of the most successful attempts to date to explain works of art by reference to their social conditions have seen it as their task to demonstrate some kind of constraining relation obtaining between the social environment and art. Thus, there have been studies of the stringencies implicit in patronage, or in the commissioning of works of art, or in the taste of a ruling clique. However, this interpretation cannot exhaust the notion of social determination: if only because it conspicuously fails to do justice to the theoretical character that is generally thought to attach to social explanation. All such explanation would be on a purely anecdotal level.

Another interpretation, therefore, suggests itself, along the following lines. To say of a particular work of art that it is socially determined, or to explain it in social terms, is to exhibit it as an instance of a constant correlation: a correlation, that is, holding between a certain form of art, on the one hand, and a certain form of social life, on the other. Thus, any particular explanation pre-

supposes a hypothesis of the form, Whenever A then B. To say in general that art is socially determined is to do no more than to subscribe to a heuristic maxim, advocating the framing and testing of such hypotheses. This interpretation obviously derives from traditional empiricism, and traditional empiricism is surely right in insisting that, as long as the hypotheses are no more than statements of constant conjunction, any explanation by reference to them in no way prejudices freedom. A work of art may be socially determined in this sense, and also display, to any degree, spontaneity, originality, expressiveness, etc. However, a fairly conclusive consideration against this interpretation of social determination is the apparent impossibility of finding plausible, let alone true, hypotheses of the required character: which may in turn be related to a specific difficulty of principle, which is that of identifying *forms* of art and *forms* of social life in such a way that they might be found to recur across history.

Accordingly, if the thesis of social determination is both to be credible and to enjoy a theoretical status, a further interpretation is required. More specifically, an interpretation is required which involves a more intimate link between the social and artistic phenomena than mere correlation. A likely suggestion is that we should look for a common component to social life and to art, which also colours and perhaps is coloured by the remaining components of which these phenomena are constituted. And we may observe among Marxist critics or philosophers of culture attempts, if of a somewhat schematic kind, to evolve such patterns of explanation: one, for instance, in terms of social consciousness, another in terms of modes or processes of labour. The one view would be that social consciousness is at once part of the

fabric of social life, and is also reflected in the art of the age. The other view would be it is the same processes of labour that occur in the infrastructure of society, where they are framed in the production relations, and also provide art with its accredited vehicles. On this latter view the difference between the worker and the artist would lie in the conditions, not in the character, of their activity. What the labourer does in an alienated fashion, at the command of another, deriving therefore neither profit nor benefit to himself from it, the artist does in comparative autonomy.

If we now ask whether social determination understood in this third way is or is not compatible with freedom and the other values of expression, the answer must lie in the detail that the specific pattern of explanation exhibits. In the case where the processes or modes of labour are the intervening factor, we perhaps already have enough of the detail to work out an answer: given, that is, we can accept a particular view of freedom and self-consciousness. A further point, however, would also seem worth making in connexion with this third interpretation of social determination: and that is that the determination now occurs on an extremely high level of generality or abstractness. The link between art and society is in the broadest terms. This may further suggest that the determination cannot be readily identified with constraint or necessity.

63

The conclusion, toward which the argument of the preceding four sections has been moving, might be put by saying that art is essentially historical. With this in mind, we might now return for the last time to the *bricoleur* problem, and see what light this throws upon it.

One point immediately suggests itself. And that is, when we consider the question asked of any particular stuff or process, Why is this an accredited vehicle of art?, we need to distinguish between two stages at which it might be raised, and accordingly between two ways in which it might be answered. In its primary occurrence we must imagine the question raised in a context in which there are as yet no arts, but to the consideration of which we perhaps bring to bear certain very general principles of art (such as those specified in section 47). In its secondary occurrence the question is raised in a context in which certain arts are already going concerns. It will be apparent that, when the question is raised in this second way, the answer it receives will in very large part be determined by the analogies and the disanalogies that we can construct between the existing arts and the art in question. In other words, the question will benefit from the comparatively rich context in which it is asked. It is, for instance, in this way that the question, Is the film an art? is currently discussed.

Last time I considered the question I argued that it gained in force or significance as the context was enriched. We can now see that the enrichment of the context is a historical matter. In consequence the question, as part of a serious or interesting inquiry, belongs to the later or more developed phases, not to the earlier phases, *a fortiori* not to the origin, of art. Yet it is paradoxically enough in connexion with the beginnings of art that it is generally raised.

64

'This', someone might exclaim, 'is more like aesthetics', contrasting the immediately preceding discussion with the dry and pedantic arguments centring around the

logical or ontological status of works of art that occupied the opening sections. Such a sentiment, though comprehensible enough, would be misguided. For it is not only from a philosophical point of view that it is necessary to get these matters as right as possible. Within art itself there is a constant preoccupation with, and in art that is distinctively early or distinctively late much emphasis upon, the kind of thing that a work of art is. Critical categories or concepts as diverse as magic, irony, ambiguity, illusion, paradox, arbitrariness, are intended to catch just this aspect of art. (And it is here perhaps that we have an explanation of the phenomenon recorded in section 11 that a painting which was not a representation of Empty Space could yet properly be entitled 'Empty Space'. For the title of this picture would be explained by reference to the reference that the picture itself makes to painting.)

It needs, however, at this stage to be pointed out that the arguments in the opening sections are less conclusive than perhaps they appeared to be. Certainly some conventional arguments to the effect that (certain) works are not (are not identical with) physical objects were disposed of. But it could be wrong to think that it follows from this that (certain) works of art are (are identical with) physical objects. The difficulty here lies in the highly elusive notion of 'identity', the analysis of which belongs to the more intricate part of general philosophy.

65

It will be observed that in this essay next to nothing has been said about the subject that dominates much contemporary aesthetics: that of the evaluation of art, and its logical character. This omission is deliberate.

Bibliography

There is little in the literature of aesthetics that can be recommended in an unqualified way. I can enumerate the works that I have found most valuable or suggestive: they are Kant's *Critique of Judgment*, the introduction to Hegel's *Philosophy of Fine Art*, Alain's *Système des Beaux-Arts*, Ernst Gombrich's *Art and Illusion* and *Meditations on a Hobby Horse*, and the essays of Adrian Stokes. I have also been deeply influenced by the thought of Freud and Wittgenstein, though their writings specifically on aesthetics are, judged by the high standards that they themselves impose, disappointing.

Most contemporary writing on aesthetics takes the form of articles. In citing these articles I employ the following abbreviations:

Aesthetics and Language, ed. William Elton (Oxford, 1954)	Elton
Aesthetics To-day, ed. Morris Philipson (Cleveland and New York, 1961)	Philipson
Philosophy Looks at the Arts, ed. J. Margolis (New York, 1962)	Margolis
Collected Papers on Aesthetics, ed. Cyril Barrett, S.J. (Oxford, 1965)	Barrett
Aesthetic Inquiry: Essays in Art Criticism and the Philosophy of Art, ed. Monroe C. Beardsley and Hubert M. Schneller (Belmont, Calif., 1967)	Beardsley
American Philosophical Quarterly	*Amer. Phil. Q.*
British Journal of Aesthetics	*B.J.A.*

Journal of Aesthetics and Art Criticism	J.A.A.C.
Journal of Philosophy	J. Phil.
Proceedings of the Aristotelian Society	P.A.S.
Proceedings of the Aristotelian Society, Supplementary Volume	Phil. and Phen.
Philosophy and Phenomenological Research	P.A.S.Supp.Vol. Res.
Philosophical Quarterly	Phil. Q.
Philosophical Review	Phil. Rev
Psychological Review	Psych. Review

Sections 2–3

For traditional treatments of the question, see e.g. Plato, *Republic*, Book X; Leo Tolstoy, *What is Art?*, trans. Aylmer Maude (Oxford, 1930); Benedetto Croce, *Aesthetic*, 2nd ed., trans. Douglas Ainslie (London, 1922); Roger Fry, *Vision and Design* (London, 1924); Ernst Cassirer, *An Essay on Man* (New Haven, 1944); Jacques Maritain, *Creative Intuition in Art and Poetry* (New York, 1953).

For the sceptical view, see Morris Weitz, *Philosophy of the Arts* (Cambridge, Mass., 1950), and 'The Role of Theory in Aesthetics', *J.A.A.C.*, Vol. XV (September 1957), pp. 27–35, reprinted in Margolis and in Beardsley; Paul Ziff, 'The Task of Defining a Work of Art', *Phil. Rev.*, Vol. LXII (January 1953), pp. 58–78; W. B. Gallie, 'Essentially Contested Concepts', *P.A.S.*, Vol. LVI (1955–6), pp. 167–98, and 'Art as Essentially Contested Concept', *Phil. Q.*, Vol. VI (April 1956), pp. 97–114; C. L. Stevenson, 'On "What Is a Poem?" ', *Phil. Rev.*, Vol. LXVI (July 1957), pp. 329–60. This approach largely derives from Ludwig Wittgenstein, *Philosophical Investigations*, ed. G. E. M. Anscombe (Oxford, 1953), e.g., pars. 65–7, and *The Blue and Brown Books* (Oxford, 1958), *passim*.

For a criticism of the extreme sceptical view, see e.g. J. Margolis, *The Language of Art and Art Criticism* (Detroit, 1965), Chap. 3; Michael Podro, 'The Arts and Recent English

Philosophy', *Jahrbuch für Asthetik und Allgemeine Kunst-wissenschaft*, Band 9 (1964), pp. 216–26.

Sections 6–8

There is a voluminous contemporary literature on the ontological status of the work of art, which is reviewed in R. Hoffmann, 'Conjectures and Refutations on the Ontological Status of the Work of Art', *Mind*, Vol. LXXI (October 1962), pp. 512–20. More generally, see e.g. Bernard Bosanquet, *Three Lectures on Aesthetics* (London, 1915), Chap. II; C. I. Lewis, *An Analysis of Knowledge and Valuation* (La Salle, Ill., 1946), Chaps. 14–15; J.-P. Sartre, *The Psychology of Imagination*, trans. anon. (New York, 1948), Part IV; Margaret Macdonald, 'Art and Imagination', *P.A.S.*, Vol. LIII (1952–3), pp. 205–26; Mikel Dufrenne, *Phénoménologie de l'Expérience Esthétique* (Paris, 1953); Jeanne Wacker, 'Particular Works of Art', *Mind*, Vol. LXIX (April 1960), pp. 223–33, reprinted in Barrett; J. Margolis, *The Language of Art and Art Criticism* (Detroit, 1965), Chap. IV; P. F. Strawson, 'Aesthetic Appraisal and Works of Art', *The Oxford Review* No. 3 (Michaelmas 1966), pp. 5–13.

Sections 11–13

On the alleged incompatibility between the physical and the representational properties of a work of art, see Samuel Alexander, *Beauty and Other Forms of Value* (London, 1933), Chap. III; and Susanne Langer, *Feeling and Form* (New York, 1953). For criticism of this view, see Paul Ziff, 'Art and the "Object of Art"', *Mind*, Vol. LX (October 1951), pp. 466–80, reprinted in Elton.

A sophisticated variant of the view, which nevertheless retains the notion of illusion, is to be found in E. H. Gombrich, *Art and Illusion* (London, 1960). On Gombrich, see Rudolf Arnheim's review of *Art and Illusion* in *Art Bulletin*,

Vol. XLIV (March 1962), pp. 75–9, reprinted in his *Towards a Psychology of Art* (Berkeley and Los Angeles, 1966); and Richard Wollheim, 'Art and Illusion', *B.J.A.*, Vol. III (January 1963), pp. 15–37.

On representation more generally, see J.-P. Sartre, *The Psychology of Imagination*, trans. anon. (New York, 1948); Vincent Tomas, 'Aesthetic Vision', *Phil. Rev.*, Vol. LXVIII (January 1959), pp. 52–67; Maurice Merleau-Ponty, *L'Œil et l'Esprit* (Paris, 1964); Richard Wollheim, *On Drawing an Object* (London, 1965); and Nelson Goodman, *Languages of Art* (Indianapolis and New York, 1968).

Section 13

On representation, seeing-as, and intention, and their inter-relations, see Ludwig Wittgenstein, *Philosophical Investigations*, ed. G. E. M. Anscombe (Oxford, 1953), Book II, xi; and Hideko Ishiguro, 'Imagination', *P.A.S. Supp. Vol.* XLII (1967) pp. 37–56.

Sections 15–19

For the first view of expression, see Eugène Véron, *Aesthetics*, trans. W. H. Armstrong (London, 1879). Véron deeply influenced Leo Tolstoy, *What is Art?*, trans. Aylmer Maude (Oxford, 1930). A latter-day version of this view occurs in Harold Rosenberg, *The Tradition of the New* (New York, 1959).

For a criticism of this view, see Susanne Langer, *Philosophy in a New Key* (Cambridge, Mass., 1942), Chap. VII, where a distinction is made between a 'symptomatic' and a 'semantic' reference to feeling; and Monroe Beardsley, *Aesthetics* (New York, 1958). See also Paul Hindemith, *A Composer's World* (Cambridge, Mass., 1952).

For the second view of expression, see I. A. Richards, *Principles of Literary Criticism* (London, 1925).

For a criticism of this view, see W. K. Wimsatt, Jr, and

Monroe Beardsley, 'The Affective Fallacy', *Sewanee Review*, LVII (Winter 1949), pp. 458–88, reprinted in W. K. Wimsatt, Jr, *The Verbal Icon* (Lexington, Ky., 1954).

A composite view is to be found in e.g. Curt J. Ducasse, *The Philosophy of Art* (New York, 1929).

On expression more generally, see John Dewey, *Art as Experience* (New York, 1934); Rudolph Arnheim, *Art and Visual Perception* (Berkeley and Los Angeles, 1954), Chap. X, and 'The Gestalt Theory of Expression', *Psych. Review*, Vol. 56 (May 1949), pp. 156–72, reprinted in his *Towards a Psychology of Art* (Berkeley and Los Angeles, 1966); Ludwig Wittgenstein, *Philosophical Investigations*, ed. G. E. M. Anscombe (Oxford, 1953); Richard Wollheim, 'Expression and Expressionism', *Revue Internationale de Philosophie*, 18 (1964), pp. 270–89, and 'Expression', *Royal Institute of Philosophy Lectures 1966–1967*, Vol. 1: *The Human Agent* (London, 1967), Chap. XIII, pp. 227–44; Nelson Goodman, *Languages of Art* (Indianapolis and New York, 1968); and Guy Sircello, *Mind and Art* (Princeton, N.J., 1972).

Sections 22–3

For the Ideal theory, see Benedetto Croce, *Aesthetic*, 2nd edn, trans. Douglas Ainslie (London, 1922); and R. G. Collingwood, *The Principles of Art* (London, 1938). In his later writings Croce considerably diverged from the theory here attributed to him.

For criticism of the theory, see W. B. Gallie, 'The Function of Philosophical Aesthetics', *Mind*, Vol LVII (1948), pp. 302–21, reprinted in Elton.

On the importance of the medium, see Samuel Alexander, *Art and the Material* (Manchester, 1925), reprinted in his *Philosophical and Literary Pieces* (London, 1939); John Dewey, *Art as Experience* (New York, 1934); Edward Bullough, *Aesthetics*, ed. Elizabeth M. Wilkinson (Stanford, 1957); and Stuart Hampshire, *Feeling and Expression* (London, 1960).

The defence of the Ideal theory in terms of 'conceived' versus 'physical' medium is to be found in John Hospers, 'The Croce–Collingwood Theory of Art', *Philosophy*, Vol. XXXI (October 1956), pp. 291–308.

On images, see Alain, *Système des Beaux-Arts* (Paris, 1926), Livre I; J.-P. Sartre, *The Psychology of Imagination*, trans. anon. (New York, 1948); and Hideko Ishiguro, 'Imagination', *British Analytical Philosophy*, ed. Alan Montefiore and Bernard Williams (London, 1966).

Section 24

For the Presentational theory, see e.g. D. W. Prall, *Aesthetic Analysis* (New York, 1936); S. C. Pepper, *The Basis of Criticism in the Arts* (Cambridge, Mass., 1945), Supplementary Essay, and *The Work of Art* (Bloomington, Ind., 1955), Chap. I; Harold Osborne, *Theory of Beauty* (London, 1952); and Monroe Beardsley, *Aesthetics* (New York, 1958).

A special variant of the theory is to be found in Susanne Langer, *Feeling and Form* (New York, 1953), and *Problems in Art* (New York, 1957).

Section 25

On the 'music of poetry', see A. C. Bradley, 'Poetry for Poetry's Sake', in *Oxford Lectures on Poetry* (London 1909); I. A. Richards, *Practical Criticism* (London, 1929); Cleanth Brooks and Robert Penn Warren, *Understanding Poetry*, rev. ed. (New York, 1950), Chap. III; Northrop Frye, *Anatomy of Criticism* (Princeton, 1957); T. S. Eliot, 'Music of Poetry', in *On Poetry and Poets* (London, 1957).

Section 26

For the Shaftesbury–Lessing Theory, see Shaftesbury, *Characteristics of Men, Manners, Opinions, Times* (1714), Chap. I; G. W. E. Lessing, *Laocoon* (1766), Chaps. 2, 3, 24 and 25.

On the depiction of movement, see also Alain, *Système des Beaux-Arts* (Paris, 1926); Rudolf Arnheim, *Art and Visual Perception* (Berkeley and Los Angeles, 1954), Chap. VIII, and 'Perceptual and Aesthetic Aspects of the Movement Response', *Journal of Personality*, Vol. 19 (1950–51), pp. 265–81 (with bibliog.), reprinted in his *Towards a Psychology of Art* (Berkeley and Los Angeles, 1966); and E. H. Gombrich, 'Moment and Movement in Art', *Journal of the Warburg and Courtauld Institutes*, Vol. 27 (1964), pp. 293–306 (with bibliog.).

Section 27

For the theory of 'tactile values', see Bernhard Berenson, *Florentine Painters of the Renaissance* (New York, 1896).

The origins of the theory are to be found in the writings of Adolf von Hildebrand, Robert Vischer and Theodor Lipps.

For the weaker version of the theory, see Heinrich Wölfflin, *Classic Art*, trans. Peter and Linda Murray (London, 1952), and *Principles of Art History*, trans. M. D. Hottinger (New York, 1932).

See also Ludwig Wittgenstein, *The Blue and Brown Books*, ed. G. E. M. Anscombe (Oxford, 1958), pp. 9–11.

Sections 28–31

For Gombrich's account of expression, see E. H. Gombrich, *Art and Illusion* (London, 1960), Chap. XI, and *Meditations on a Hobby Horse* (London, 1963). See also Richard Wollheim, 'Expression and Expressionism', *Revue Internationale de Philosophie*, 18 (1964), pp. 270–89, and Preface to Adrian Stokes, *The Invitation in Art* (London, 1965).

On the iconicity or 'immanence' of works of art, see George Santayana, *The Sense of Beauty* (New York, 1896); Carroll C. Pratt, *Meaning in Music* (New York, 1931); Samuel Alexander, *Beauty and Other Forms of Value* (London, 1933); Morris Weitz, *Philosophy of the Arts* (Cam-

bridge, Mass., 1950); and Ernst Cassirer, *Philosophy of Symbolic Forms*, trans. Ralph Manheim (New Haven, 1953–7).

Attempts to give this account a more rigorous formulation are to be found in Susanne Langer, *Philosophy in a New Key* (Cambridge, Mass., 1942), and *Feeling and Form* (New York, 1953); and C. W. Morris, 'Esthetics and the Theory of Signs', *Journal of Unified Science*, 8 (1939), pp. 13–50. Both Morris and Langer are criticized (by C. L. Stevenson) in *Language, Thought and Culture*, ed. P. Henlé (Ann Arbor, 1958), Chap. 8. See also Richard Rudner, 'On Semiotic Aesthetics', *J.A.A.C.*, Vol. X (September 1951), pp. 67–77, reprinted in Beardsley. On Langer, see Ernst Nagel's review of *Philosophy in a New Key*, *J. Phil.*, Vol. XL (10 June 1943), pp. 323–9, reprinted as 'A Theory of Symbolic Form', in his *Logic without Metaphysics* (Glencoe, Ill., 1956); Arthur Szathmary, 'Symbolic and Aesthetic Expression in Painting', *J.A.A.C.*, Vol. XIII (September 1954), pp. 86–96; and P. Welsh, 'Discursive and Presentational Symbols', *Mind*, Vol. LXIV (April 1955), pp. 181–99. On Morris, see Benbow Ritchie, 'The Formal Structure of the Aesthetic Object', *J.A.A.C.*, Vol. III (April 1943), pp. 5–15; and Isabel P. Creed, 'Iconic Signs and Expressiveness', *J.A.A.C.*, Vol. III (April 1943), pp. 15–21. Morris withdrew from the view that art can be distinguished by reference to a special class of sign in *Signs, Language and Behavior* (New York, 1946).

The distinction between symbol and icon as kinds of sign goes back to Charles S. Peirce, *Collected Papers* (Cambridge, Mass., 1931–5), Vol. II, Book II, Chap. 3.

On the notion of style, see Heinrich Wölfflin, *Principles of Art History*, trans. M. D. Hottinger (New York, 1932), and *Classic Art*, trans. Peter and Linda Murray (London, 1952). More generally, see Meyer Schapiro, 'Style', in *Anthropology To-day*, ed. A. L. Kroeber (Chicago, 1953), reprinted in Philipson; James S. Ackerman, 'Style', in James S. Ackerman and Rhys Carpenter, *Art and Archaeology* (London, 1963). See also Paul Frankl, *Das System der Kunstwissenschaft* (Leipzig, 1938), and *The Gothic* (Princeton, N.J., 1960).

Section 32

For the argument against genres or aesthetic categories, see Benedetto Croce, *Aesthetic*, 2nd ed., trans. Douglas Ainslie (London, 1922), Chaps. 12 and 15, and *Breviary of Aesthetic*, trans. Douglas Ainslie (Houston, Texas, 1915). The issues are reviewed in René Wellek and Austin Warren, *Theory of Literature* (New York, 1949), Chap. 17.

For the argument that would connect genre-classification and the criteria of evaluation, see Harold Osborne, *Aesthetics and Criticism* (London, 1955).

For the defence of genre-criticism, see Northrop Frye, *The Anatomy of Criticism* (Princeton, 1957). See also William Empson, *Some Versions of Pastoral* (London, 1935); and R. S. Crane, *The Languages of Criticism and the Structure of Poetry* (Toronto, 1953). A most interesting discussion is to be found in Kendall L. Walton, 'Categories of Art', *Phil. Rev.*, Vol. LXXIX (July 1970), pp. 334–67.

For the insistence on the particularity of a work of art, see e.g. Stuart Hampshire, 'Logic and Appreciation', *World Review* (1953), reprinted in Elton.

Section 33

For the view that knowledge of the problem to which the work of art is a solution is essential to aesthetic understanding, see Erwin Panofsky, 'The History of Art as a Humanistic Discipline', in his *Meaning in the Visual Arts* (New York, 1955). Also Ernst Gombrich, *The Story of Art* (London, 1950); and Arnold Hauser, *The Philosophy of Art History* (London, 1959).

For criticism of this, see Edgar Wind, 'Zur Systematik der Künstlerischen Probleme', *Zeitschrift für Aesthetik und allgemeine Kunstwissenschaft*, Vol. XVIII (1925), pp. 438–86; and a much publicized article by Monroe Beardsley and W. K. Wimsatt, Jr, 'The Intentional Fallacy', *Sewanee Review*, LIV (Summer 1946), pp. 468–88, reprinted in W. K. Wimsatt, Jr, *The Verbal Icon* (Lexington, Ky., 1954)

and also in Margolis. The discussion is taken up in e.g. Isabel Hungerland, 'The Concept of Intention in Art Criticism', *J. Phil.*, Vol. LII (New York, 1955), pp. 733–42; F. Cioffi, 'Intention and Interpretation in Criticism', *P.A.S.*, Vol. LXIV (1963–4), pp. 85–106, reprinted in Barrett; John Kemp, 'The Work of Art and the Artist's Intentions', *B.J.A.*, Vol. IV (April 1964) pp. 146–54, and Anthony Savile, 'The Place of Intention in the Concept of Art', *P.A.S.*, Vol. LXIX (1968–9), pp. 101–24.

Sections 35–6

On types and tokens, see Charles Sanders Peirce, *Collected Papers* (Cambridge, Mass., 1931–5), Vol. IV, pars. 537 ff.

See also Margaret Macdonald, 'Some Distinctive Features of the Arguments Used in Criticism of the Arts', *P.A.S. Supp. Vol.* XXIII (1949), pp. 183–94, reprinted in a revised form in Elton; R. Rudner, 'The Ontological Status of the Aesthetic Object', *Phil. and Phen. Res.*, Vol. X (March 1950), pp. 380–88; C. L. Stevenson, 'On "What Is a Poem?" ', *Phil. Rev.*, Vol. LXVI (July 1957), pp. 329–60; J. Margolis, *The Language of Art and Art Criticism* (Detroit, 1965); P. F. Strawson, 'Aesthetic Appraisal and Works of Art', *The Oxford Review* No. 3 (Michaelmas 1966), pp. 5–13.

Sections 37–9

On interpretation, see Paul Valéry, 'Reflections on Art', printed in his *Collected Works*, trans. Ralph Manheim (London, 1964), Vol. XIII.

See also William Empson, *Seven Types of Ambiguity* (London, 1930); Ernst Kris and Abraham Kaplan, 'Aesthetic Ambiguity', in Ernest Kris, *Psychoanalytic Explorations in Art* (New York, 1952).

On the eliminability of interpretation, see Susanne Langer, *Feeling and Form* (New York, 1953). This view is criticized in Jeanne Wacker, 'Particular Works of Art', *Mind*, Vol. LXIX (1960), pp. 223–33, reprinted in Barrett.

For the distinction between interpretation and description,

see Morris Weitz, *Hamlet and the Philosophy of Literary Criticism* (Chicago, 1964); Charles L. Stevenson, 'On the "Analysis" of a Work of Art', *Phil. Rev.*, Vol. LXVII (January 1958), pp. 33–51, and 'On the Reasons that can be given for the Interpretation of a Poem', printed in Margolis; W. K. Wimsatt, Jr, 'What to say about a Poem', in his *Hateful Contraries* (Lexington, Ky., 1965); and the contributions by Monroe Beardsley and Stuart Hampshire to *Art and Philosophy*, ed. Sidney Hook (New York, 1966).

For the suggestion that the two kinds of interpretation are related, see Margaret Macdonald, 'Some Distinctive Features of Arguments used in Criticism of the Arts', *P.A.S. Supp. Vol.* XXIII (1949), pp. 183–94, reprinted (in a revised form) in Elton; and J. Margolis, *The Language of Art and Art Criticism* (Detroit, 1965).

Sections 40–42

The thesis that art may be defined in terms of our attitude towards it, or 'the aesthetic consciousness', is most clearly formulated in Edward Bullough, *Aesthetics*, ed. Elizabeth M. Wilkinson (Stanford, 1957). The forerunners of this approach are Immanuel Kant, *Critique of Judgment*, trans. J. C. Meredith (Oxford, 1928); and Arthur Schopenhauer, *The World as Will and Idea*, trans. R. B. Haldane and J. Kemp (London, 1883).

For more recent discussions, see H. S. Langfeld, *The Aesthetic Attitude* (New York, 1920); J. O. Urmson, 'What Makes a Situation Aesthetic', *P.A.S. Supp. Vol.* XXXI (1957), pp. 75–92, reprinted in Margolis, which attempts a linguistic formulation of the thesis; and F. E. Sparshott, *The Structure of Aesthetics* (Toronto, 1963).

See also Virgil C. Aldrich, *Philosophy of Art* (Englewood Cliffs, N.J., 1963), which defines art in terms of a special mode of perception; and Stanley Cavell, 'The Avoidance of Love: a Reading of *King Lear*', in his *Must We Mean What We Say?* (New York, 1969).

An interesting development of this approach from a phenomenological point of view is to be found in Mikel Dufrenne, *Phénoménologie de l'Expérience Esthétique* (Paris, 1953).

For a criticism of this approach, see George Dickie, 'The Myth of the Aesthetic Attitude', *Amer. Phil. Q., I* (January 1964), pp. 54–65; and Marshall Cohen 'Aesthetic Essence', in *Philosophy in America*, ed. Max Black (New York, 1965).

For the view that all objects can be seen aesthetically, see e.g. Stuart Hampshire, 'Logic and Appreciation', in *World Review* (1952), reprinted in Elton. Cf. Paul Valéry, 'Man and the Sea Shell', in his *Collected Works*, trans. Ralph Manheim (London, 1964), Vol. XIII.

Section 43

See John Dewey, *Art as Experience* (New York, 1934). For an extreme or crude version of the view that life and art are distinct, see Clive Bell, *Art* (London, 1914). Such an approach is (rather ambiguously) criticized in I. A. Richards, *Principles of Literary Criticism* (London, 1925).

Section 44

On the concept of art in primitive society, see Yrjö Hirn, *The Origins of Art* (London, 1900); Franz Boas, *Primitive Art* (Oslo, 1927); Ruth Bunzel, 'Art', in *General Anthropology*, ed. Franz Boas (New York, 1938); E. R. Leach, 'Aesthetics', in *The Institutions of Primitive Society*, ed. E. E. Evans-Pritchard (Oxford, 1956); Margaret Mead, James B. Bird and Hans Himmelheber, *Technique and Personality* (New York, 1963); and Claude Lévi-Strauss, *The Savage Mind*, trans. anon. (London, 1966). See also André Malraux, *The Voices of Silence*, trans. Stuart Gilbert (London, 1954).

On the modern concept of art, see P. O. Kristeller, 'The Modern System of the Arts: A Study in the History of Aesthetics', *Journal of the History of Ideas*, Vol. XII (October

1951), pp. 496–527, and Vol. XIII (January 1952), pp. 17–46. Cf. W. Tatarkiewicz, 'The Classification of the Arts in Antiquity', *Journal of the History of Ideas*, Vol. XXIV (April 1963), pp. 231–40; and Meyer Schapiro, 'On the Aesthetic Attitude in Romanesque Art', in *Art and Thought: Issued in Honour of Dr Ananda K. Coomaraswamy*, ed. K. Bharatha Iyer (London, 1947).

Section 45

For the notion of form of life, see Ludwig Wittgenstein, *Philosophical Investigations* (Oxford, 1953).

For the analogy between art and language, see John Dewey, *Art as Experience* (New York, 1934); André Malraux, *The Voices of Silence*, trans. Stuart Gilbert (London, 1954); E. H. Gombrich, *Art and Illusion* (London, 1960); and Maurice Merleau-Ponty, 'Indirect Language and the Voices of Silence', in his *Signs*, trans. Richard C. McCleary (Evanston, Ill., 1964).

For the reciprocity between artist and spectator, which is the theme of much of this essay, see Alain, *Système des Beaux-Arts* (Paris, 1926); John Dewey, *Art as Experience* (New York, 1934); also (surprisingly enough) R. G. Collingwood, *The Principles of Art* (London, 1938); and Mikel Dufrenne, *Phénoménologie de l'Expérience Esthétique* (Paris, 1953). Many of the crucial insights are to be found in G. W. F. Hegel, *Philosophy of Fine Art: Introduction*, trans. Bernard Bosanquet (London, 1886).

Section 46

For the idea of an artistic impulse, see e.g. Samuel Alexander, *Art and Instinct* (Oxford, 1927), reprinted in his *Philosophical and Literary Pieces* (London, 1939); and Étienne Souriau, *L'Avenir de l'Esthétique* (Paris, 1929).

A nineteenth-century version of this approach took the form of tracing art to a play-impulse. This approach, which

derives rather tenuously from Friedrich Schiller, *Letters on the Aesthetic Education of Man*, trans. Reginald Snell (New Haven, 1954), is to be found in Herbert Spencer, *Essays* (London, 1858–74); Konrad Lange, *Das Wesen der Kunst* (Berlin, 1901); and Karl Groos, *The Play of Man*, trans. Elizabeth L. Baldwin (New York, 1901).

Another version of this approach in terms of a specific *Kunstwollen* or artistic volition is to be found in Alois Riegl, *Stilfragen* (Berlin, 1893); and Wilhelm Worringer, *Abstraction and Empathy*, trans. Michael Bullock (London, 1953).

For criticism of the whole approach, see Mikel Dufrenne, *Phénoménologie de l'Expérience Esthétique* (Paris, 1953).

Section 47

There are scattered implicit references to the *bricoleur* problem in Immanuel Kant, *Critique of Judgment*, trans. J. C. Meredith (Oxford, 1928); G. W. F. Hegel, *Philosophy of Fine Art: Introduction*, trans. Bernard Bosanquet (London, 1886); John Dewey, *Art as Experience* (New York, 1934). See also D. W. Prall, *Aesthetic Judgment* (New York, 1929); T. M. Greene, *The Arts and the Art of Criticism* (Princeton, 1940); Thomas Munro, *The Arts and their Interrelations* (New York, 1940).

Section 48

For the argument that, if a work of art expresses anything, it must express something otherwise identifiable, see Eduard Hanslick, *The Beautiful in Music*, trans. Gustav Cohen (New York, 1957). Hanslick's assumptions are criticized, somewhat perfunctorily, in Carroll C. Pratt, *The Meaning of Music* (New York, 1931), and Leonard B. Meyer, *Emotion and Meaning in Music* (Chicago, 1956). A view diametrically opposed to Hanslick is to be found in J. W. N. Sullivan, *Beethoven: His Spiritual Development* (London, 1927).

See also Ludwig Wittgenstein, *Philosophical Inves-*

tigations, ed. G. E. M. Anscombe (Oxford, 1953), *I*, paras. 519–46, *II*, vi, ix, and *The Blue and Brown Books* (Oxford, 1958), pp. 177–85, and *Letters and Conversations on Aesthetics, etc.*, ed. Cyril Barrett (Oxford, 1966), pp. 28–40.

Section 49

The argument against paraphrasability is to be found in Cleanth Brooks and Robert Penn Warren, *Understanding Fiction* (New York, 1943), and Cleanth Brooks, *The Well-Wrought Urn* (New York, 1947).

The position is criticized in Yvor Winters, *In Defence of Reason* (Denver, 1947).

See also Stanley Cavell, 'Aesthetic Problems of Modern Philosophy', in *Philosophy in America*, ed. Max Black (New York, 1965), reprinted in his *Must We Mean What We Say?* (New York, 1969).

Section 50

For a criticism of the identification of the artist's achievement with the having of images, see Alain, *Système des Beaux-Arts* (Paris, 1926), Livre I; J.-P. Sartre, *The Psychology of the Imagination*, trans. anon. (New York, 1948); Henri Foçillon, *The Life of Forms in Art*, trans. Charles Beecher Hogan (New York, 1948).

For the distinction between the artist and the neurotic, see Sigmund Freud, *Introductory Lectures in Psycho-Analysis*, trans. Joan Rivière (London, 1929), Lecture 23, and 'Formulations concerning the two Principles in Mental Functioning' and 'The Relation of the Poet to Day Dreaming', in *Collected Papers*, ed. Ernest Jones (London, 1949), Vol. IV.

See also Marion Milner, *On Not Being Able to Paint*, 2nd ed. (London, 1957); and Hanna Segal, 'A Psycho-Analytic Approach to Aesthetics', and Adrian Stokes, 'Form in Art', both in *New Directions in Psycho-Analysis*, ed. Melanie Klein *et al.* (London, 1955).

Section 51

For the notion of understanding in connexion with art, see e.g. Susanne Langer, *Philosophy in a New Key* (Cambridge, Mass., 1942); C. I. Lewis, *An Analysis of Knowledge and Valuation* (La Salle, Ill., 1946); Richard Rudner, 'On Semiotic Aesthetics', *J.A.A.C.*, Vol. X (September 1951), pp. 67–77, reprinted in Beardsley, and 'Some Problems of Nonsemiotic Aesthetics', *J.A.A.C.*, Vol. XV (March 1957), pp. 298–310; Rudolf Wittkower, 'Interpretation of Visual Symbols in the Arts', in A. J. Ayer *et al.*, *Studies in Communication* (London, 1955); *Language, Thought and Culture*, ed. P. Henlé (Ann Arbor, 1958), Chap. 9; John Hospers, *Meaning and Truth in the Arts* (Hamden, Conn., 1964).

See also Ludwig Wittgenstein, *Lectures and Conversations on Aesthetics, etc.*, ed. Cyril Barrett (Oxford, 1966).

Section 53

See Ernst Kris, *Psychoanalytic Exploration in Art* (New York, 1952). See also E. H. Gombrich, 'Psycho-Analysis and the History of Art', *International Journal of Psycho-Analysis*, Vol. XXXV (October 1954), pp. 401–11, reprinted in his *Meditations on a Hobby Horse* (London, 1963), and 'Freud's Aesthetics', *Encounter*, Vol. XXVI (January 1966), pp. 30–40.

Section 54

See Adrian Stokes, *Three Essays on the Painting of Our Time* (London, 1961), *Painting and the Inner World* (London, 1963), and *The Invitation in Art* (London, 1965).

Section 56

For the application of information theory to aesthetics, see Leonard B. Meyer, 'Meaning in Music and Information

Theory', *J.A.A.C.*, Vol. XV (June 1957), pp. 412–24, and 'Some Remarks on Value and Greatness in Music', *J.A.A.C.*, Vol. XVII (June 1959), pp. 486–500, reprinted in Philipson and in Beardsley. See also Monroe Beardsley, *Aesthetics* (New York, 1958), pp. 215–17; and E. H. Gombrich, 'Art and the Language of the Emotions', *P.A.S. Supp. Vol.* XXXVI (1962), pp. 215–34, reprinted as 'Expression and Communication' in his *Meditations on a Hobby Horse* (London, 1963).

Section 57

For the distinction between cognitive or referential and emotive meaning and its application to aesthetic theory, see C. K. Ogden and I. A. Richards, *The Meaning of Meaning* (London, 1923); and I. A. Richards, *Principles of Literary Criticism* (London, 1925). The theory has, of course, been widely discussed, but, for its relevance to aesthetic theory, see William Empson, *Structure of Complex Words* (London, 1951); and *Language, Thought and Culture*, ed. P. Henlé (Ann Arbor, 1958), Chaps. 5 and 6.

For the view that poetry is a verbal structure, see e.g. W. R. Wimsatt, Jr, *The Verbal Icon* (Lexington, Ky., 1954). For a more radical view, which involves a contrast between language (*langue*) and literature or writing (*écriture*), see Roland Barthes, *Writing Degree Zero*, trans. Annette Lavers and Colin Smith (London, 1967).

Section 59

For a historical account of the classical conception of order in the visual arts, see Rudolf Wittkower, *Architectural Principles in the Age of Humanism* (London, 1949). Contemporary attempts to revive the Renaissance or mathematical conception are to be found in George D. Birkhoff, *Aesthetic Measure* (Cambridge, Mass., 1933); and Le Corbusier, *The Modulor*, trans. Peter de Francia and Anna Bostock (London, 1951).

An explication of the notion of order in terms of *Gestalt* psychology is attempted by Kurt Koffka, 'Problems in the Psychology of Art', in *Art: A Bryn Mawr Symposium* (Bryn Mawr, 1940); and Rudolf Arnheim, *Art and Visual Perception* (Berkeley and Los Angeles, 1954), and 'A Review of Proportion', *J.A.A.C.*, Vol. XIV (September 1955), pp. 44–57, reprinted in his *Towards a Psychology of Art* (Berkeley and Los Angeles, 1966). This approach is criticized in Anton Ehrenzweig, *The Psycho-Analysis of Artistic Hearing and Vision* (London, 1953); and Harold Osborne, 'Artistic Unity and Gestalt', *Phil. Q.*, Vol. 14 (July 1964), pp. 214–28.

For critical discussion of the notion of artistic unity, see E. H. Gombrich, 'Raphael's *Madonna della Sedia*' (London 1956), reprinted in his *Norm and Form* (London, 1966); and a brilliant essay by Meyer Schapiro, 'On Perfection, Coherence, and Unity of Form and Content', in *Art and Philosophy*, ed. Sidney Hook (New York, 1966).

Sections 60–61

On the essentially historical or transformational character of art, see Heinrich Wölfflin, *Principles of Art History*, trans. M. D. Hottinger (London, 1932); Henri Foçillon, *Life of Forms in Art*, trans. Charles Beecher Hogan (New York, 1948); André Malraux, *The Voices of Silence*, trans. Stuart Gilbert (London, 1954); Arnold Hauser, *The Philosophy of Art History* (London, 1959). See also Meyer Schapiro, 'Style', in *Anthropology To-day*, ed. A. Kroeber (Chicago, 1953), reprinted in Philipson.

Section 62

For the social theory of art, the classical texts are Karl Marx, *Economic and Philosophic Manuscripts of 1844*, trans. Martin Milligan (Moscow, 1959); Friedrich Engels, 'Ludwig Feuerbach and the End of a Classical German Philosophy', in Karl Marx and Friedrich Engels, *Basic Writings on Politics*

and Philosophy, ed. Lewis S. Feuer (New York, 1959); G. Plekhanov, *Art and Social Life*, trans. Eleanor Fox *et al.* (London, 1953); William Morris, *Selected Writings*, ed. Asa Briggs (London, 1962).

See also F. Antal, 'Remarks on the Methods of Art History', *Burlington Magazine*, Vol. XCI (February–March 1949), pp. 49–52 and 73–5; Richard Wollheim, 'Sociological Explanation of the Arts: Some Distinctions', *Atti del III Congresso Internazionale di Estetica* (Turin, 1957), pp. 404–10 (with bibliog.); Ernst Fischer, *The Necessity of Art*, trans. Anna Bostock (London, 1963).

Section 64

For the interaction between art and theories or conceptions of art, see e.g. André Malraux, *The Voices of Silence*, trans. Stuart Gilbert (London, 1954); Michel Butor, 'Le Livre comme Objet', *Critique*, Vol. XVIII (1962), pp. 929–46; Maurice Merleau-Ponty, 'Indirect Language and the Voices of Silence', in his *Signs*, trans. Richard C. McCleary (Evanston, Ill., 1964); Paul Valéry, 'The Creation of Art' and 'The Physical Aspects of a Book', in his *Collected Works*, trans. Ralph Manheim (London, 1964), Vol. XIII; Michael Fried, *Three American Painters* (Cambridge, Mass., 1965); Harold Rosenberg, *The Anxious Object* (London, 1965); Claude Lévi-Strauss, *The Savage Mind*, trans. anon. (London, 1966); Leo Steinberg, 'Contemporary Art and the Plight of its Public', *Harper's Magazine*, reprinted in *The New Art: a Critical Anthology*, ed. Geoffrey Battcock (New York, 1966); Adrian Stokes, *Reflections on the Nude* (London, 1967); Stanley Cavell, 'Music Discomposed', in *Art, Mind, and Religion*, ed. W. H. Capitan and D. D. Merrill (Pittsburgh, 1967), reprinted in his *Must We Mean What We Say?* (New York, 1969), and *The World Viewed* (New York, 1971); and Richard Wollheim, 'The Work of Art as Object', *Studio International*, Vol. 180, No. 928 (1970), pp. 231–5, reprinted in his *On Art and the Mind* (London, 1973).

More About Penguins
and Pelicans

Penguinews, which appears every month, contains
details of all the new books issued by Penguins
as they are published. From time to time it is
supplemented by *Penguins in Print*, which is our
complete list of almost 5,000 titles.

A specimen copy of *Penguinews* will be sent to you
free on request. Please write to Dept EP, Penguin
Books Ltd, Harmondsworth, Middlesex, for your copy.

In the U.S.A.: For a complete list of books available
from Penguins in the United States write to Dept CS,
Penguin Books, 625 Madison Avenue, New York,
New York 10022.

In Canada: For a complete list of books available from
Penguins in Canada write to Penguin Books Canada Ltd,
2801 John Street, Markham, Ontario L3R 1B4.

A Heritage of Images

Fritz Saxl

These lectures of Renaissance and Reformation art were delivered by Fritz Saxl during the fifteen years before his death in 1948.

Although concerned with all forms of historical material, Saxl here discusses the importance of imagery in the history of art. He traces the development and expansion of the fine arts in Renaissance Italy, particularly in Venice, and he discusses the revival of interest in antique astrology, pagan imagery and classical mythology through humanist artists such as Bellini, Mantegna, Tintoretto, Titian and Rubens.

A generous selection of illustrations, many of them rare, accompanies the text.

Meaning in the Visual Arts

Erwin Panofsky

Erwin Panofsky ranked among the foremost art historians of this or any century. *Meaning in the Visual Arts* must be one of the few books which began as a compilation of essays and became a classic of art history.

The topics he handles here, apart from the whole theory of iconography and iconology, include aspects of the work of Titian, Poussin, and Dürer, the life of Abbot Suger of Saint-Denis, the theory of human proportions, and the intriguing first page of Vasari's *Libro*.

The large number of illustrations in this edition have been selected to supplement and explain Panofsky's intricate arguments.

Not for sale in the U.S.A. or Canada